C000217663

The Best of MAC
2000–2010

THE POLITICAL YEARS
A Decade of Cartoons from the *Daily Mail*

Stan McMurtry **mac**
Edited by Mark Bryant

PORTICO

For my fantastic children, grandchildren and wonderful wife, Liz

Published in the United Kingdom in 2010 by
Portico Books
10 Southcombe Street
London
W14 0RA

An imprint of Anova Books Company Ltd

ISBN 978-1-907554-0-56

A CIP catalogue record for this book is available from the British Library.

10 9 8 7 6 5 4 3 2 1

Printed and bound by WS Bookwell, Finland

This book can be ordered direct from the publisher at www.anovabooks.com

PREFACE

What a tumultuous year we've had in politics. Gordon Brown leaving office, a new coalition Government, and a horrifying global recession. With a calamitous bit of bad timing, I chose to go on holiday the day after May's General Election and missed having the opportunity to draw cartoons about Gordon's departure and Nick Clegg's unexpected and sudden elevation to Deputy Prime Minister.

Instead, I sat on my sunbed sipping an iced drink and watched the sun go down behind the small boats in the harbour, cursing that I was not at my drawing-board, chewing my pencil and struggling to meet a deadline. But alas, these are the trials and tribulations we cartoonists sometimes have to endure.

This book is a compilation covering ten years of cartoons that are, in the main, light-hearted comments relating to political events of the time. Over the recent months, I have never felt the inclination to draw thunderous clouds moving across the UK with the words 'Looming Recession' written on them, or vast angry seas threatening to engulf the populace bearing the legend 'Rising Inflation'. It's my opinion that the best cartoons are those that make a point while at the same time raising a chuckle or a smile. There are, after all, so many depressing events in the news nowadays that I feel it is my job to lighten the gloom a little.

As some of you may know, I spend most of my time deciding where to hide a small caricature of my wife Liz in the drawing. She doesn't appear in the really serious or sad cartoons, but she has become an important addition each day and I get letters of complaint from readers who can't find her.

So enjoy looking and, more importantly, I hope you'll enjoy the cartoons!

MAC

As the problems of Tony Blair's Labour government deepened, the Minister for Science, Lord Sainsbury, reported that he had appointed a team of experts to examine the risk of Earth being hit by asteroids and to set up early warning systems like those in the USA and Japan.

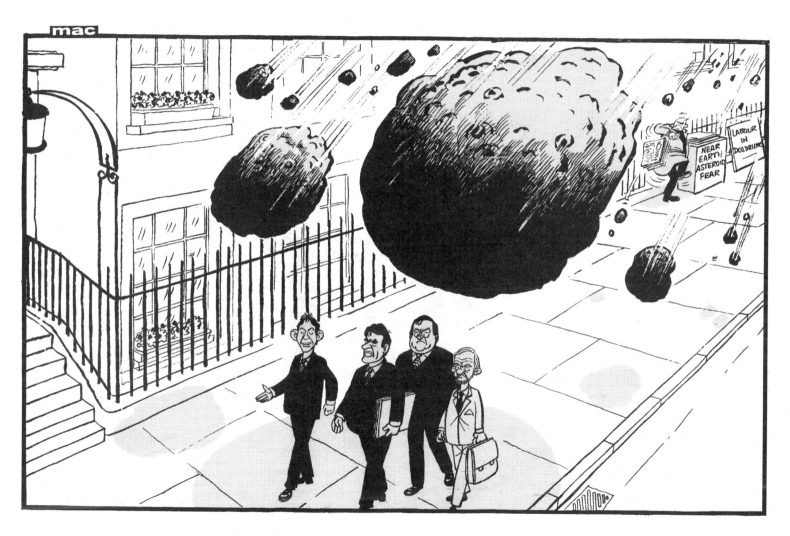

'Look on the bright side, chaps. Things can't get any worse.' *19 September 2000*

Shadow Home Secretary Ann Widdecombe's 'zero tolerance' policy on drugs – including mandatory £100 fines for possession of cannabis – lay in tatters when seven of her front-bench colleagues admitted that they had tried cannabis in their youth.

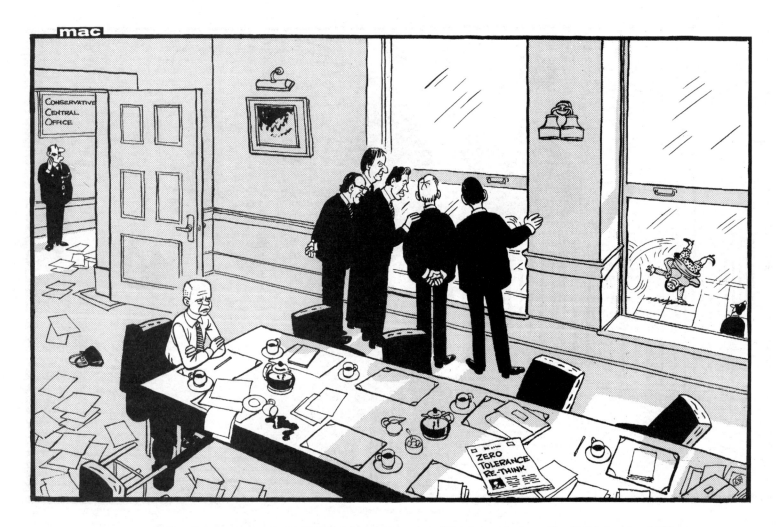

'All right, own up. Who slipped cannabis into Ann Widdecombe's coffee?' *10 October 2000*

There were accusations of sleaze when it was discovered that some of the Government's recently ennobled peers – as well as the most favoured bidder for taking over the Dome – had made substantial donations to the Labour Party.

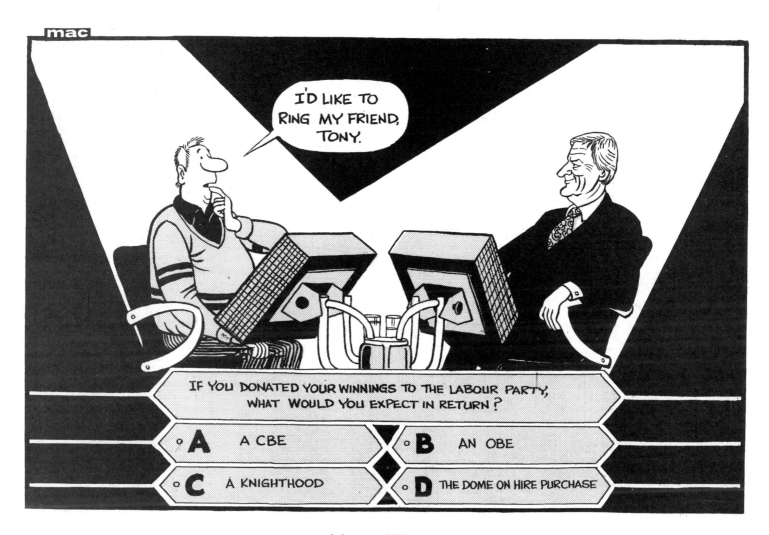

8 January 2001

The Lord Chancellor, Lord Irvine, appeared to compromise his political neutrality as head of the judiciary when he invited barristers to a Labour Party fundraising dinner and suggested that £200 per head should be the minimum donation.

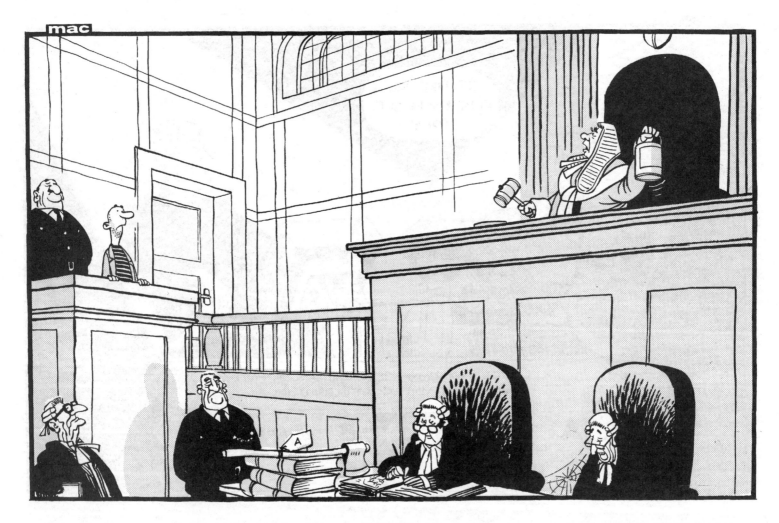

'Before I pass sentence, is there any advance on the measly donation you've promised to Labour Party funds?
... £200 ... do I hear £400?' *20 February 2001*

As the political parties geared up for the forthcoming General Election campaign, Tory leader William Hague pledged that he would reintroduce the Married Couple's Allowance scrapped by Labour in 2000 if his party was returned to power.

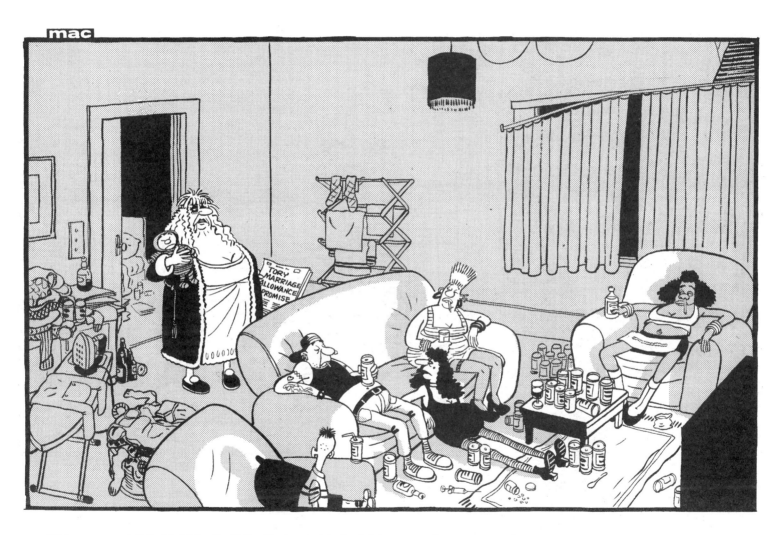

'Things are a bit tight, kids. So if the Tories get in I might marry whoever one of your fathers is.' *22 February 2001*

Home Secretary Jack Straw introduced emergency legislation to defer local council elections and the General Election until 7 June because of the foot-and-mouth crisis.

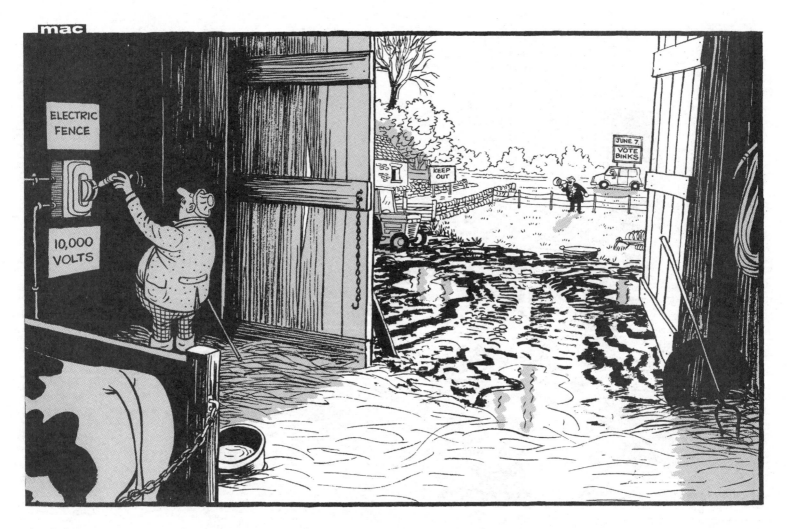

'Hello...Cooeee! I'm canvassing on behalf of...' *3 April 2001*

The Labour Party launched its manifesto, *Ambitions for Britain*, in which it pledged to smash the 'glass ceiling' that held the nation back and called for a 'marriage of economic prosperity and social justice' to allow the 'talents of everyone' to flourish.

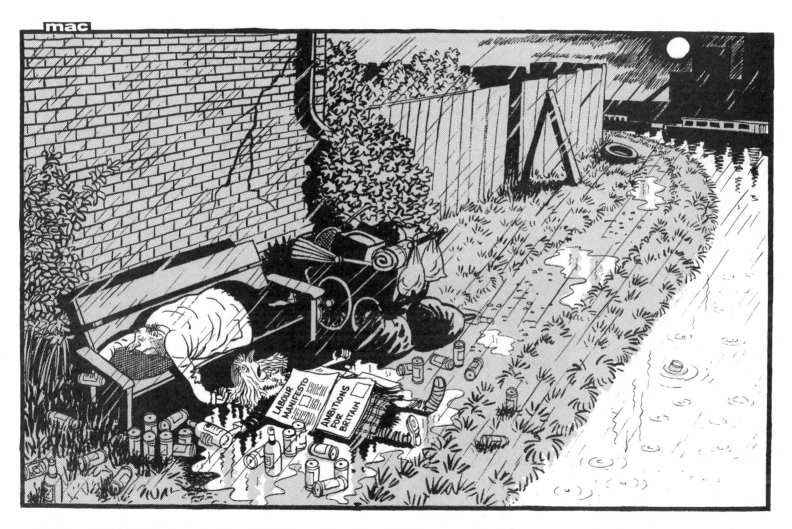

'Wake up, Ron. That glass ceiling what's been stoppin' us fulfilling our potential has sprung a leak again.' *17 May 2001*

In the event the election was won by a landslide victory to Labour. Gaining 413 seats in Parliament it was also the first time that the Labour Party had been elected for a consecutive full term. William Hague immediately resigned as Tory Party leader.

'Isn't it exciting? After all these weeks we're going to see Daddy again.' *8 June 2001*

Contenders who threw their hats into the ring for leadership of the Conservative Party included Shadow Chancellor Michael Portillo, Shadow Defence Secretary Iain Duncan Smith, former Chancellor Kenneth Clarke, right-winger David Davis and Party Chairman Michael Ancram.

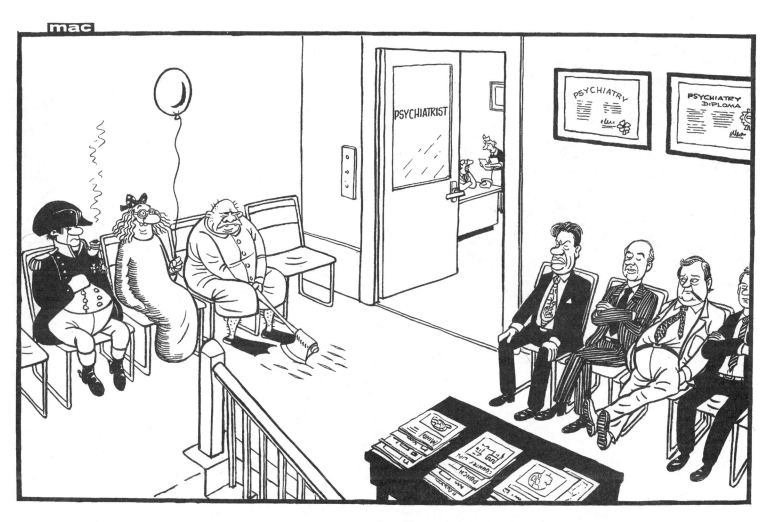

'Today you've got one Napoleon, a woman who thinks she's a sausage, a mad axeman and some poor souls who want to lead the Tory Party.' *18 June 2001*

Soon after taking office as the new Speaker of the House of Commons, Glaswegian Michael Martin – former union official 'Gorbals Mick' – was accused of sacking his predecessor's Diary Secretary for being 'too posh'.

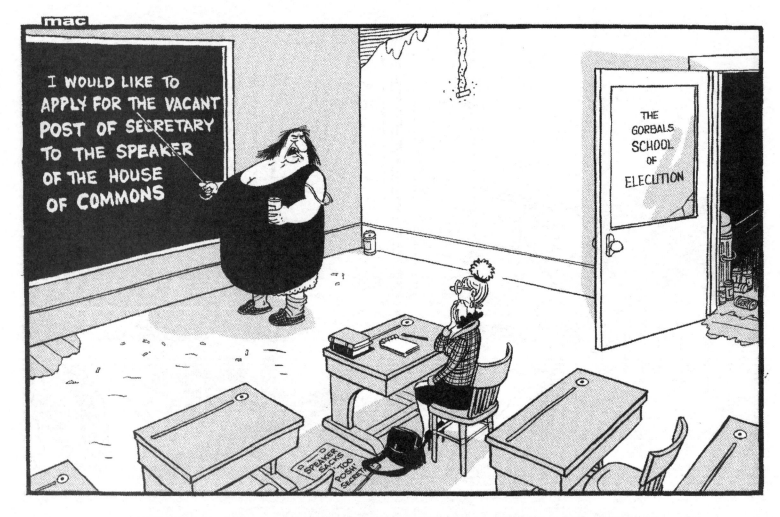

'Enunciate, woman, enunciate! You have to impress the man. Now, try again..."Gissa job, Jimmy, or ah'll heed butt yer teeth oot!" ' *5 November 2001*

Sleaze watchdog, Elizabeth Filkin, who had been appointed as Parliamentary Commissioner for Standards in 1999, resigned after claiming that she had been the victim of a smear campaign and had been obstructed while trying to carry out her job.

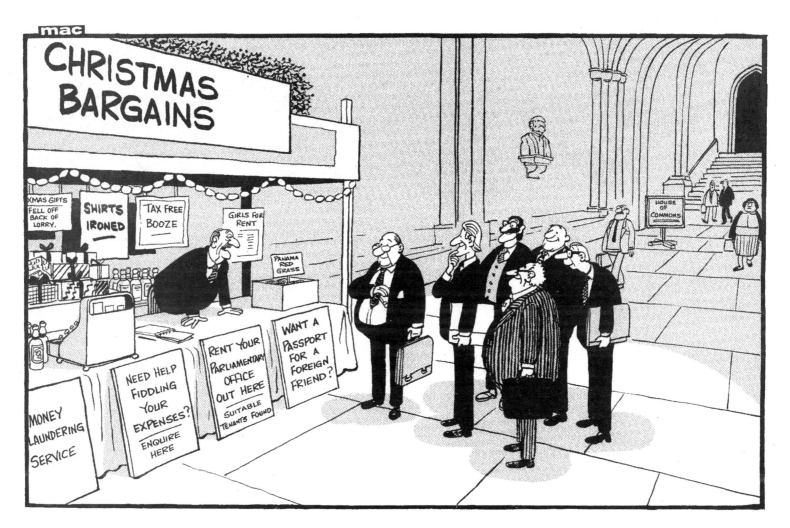

'Of course, this is only until we've elected a new standards watchdog.' *6 December 2001*

There were more accusations of sleaze when it was reported that Prime Minister Tony Blair had personally supported a bid by Indian billionaire Lakshmi Mittal over a Romanian steel deal only weeks after Mittal had donated £125,000 to the Labour Party.

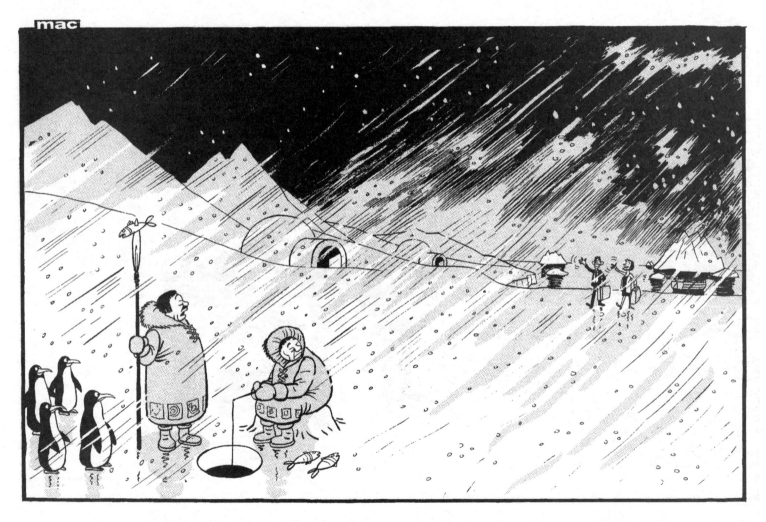

'Hello. Another tour. There must be some more sleaze at home.' *12 February 2002*

As street-crime figures in Britain reached a new high, Rural Affairs Minister Alun Michael announced that though stag-hunting and hare-coursing would be banned, fox-hunting with dogs would be allowed to continue as a means of pest control only.

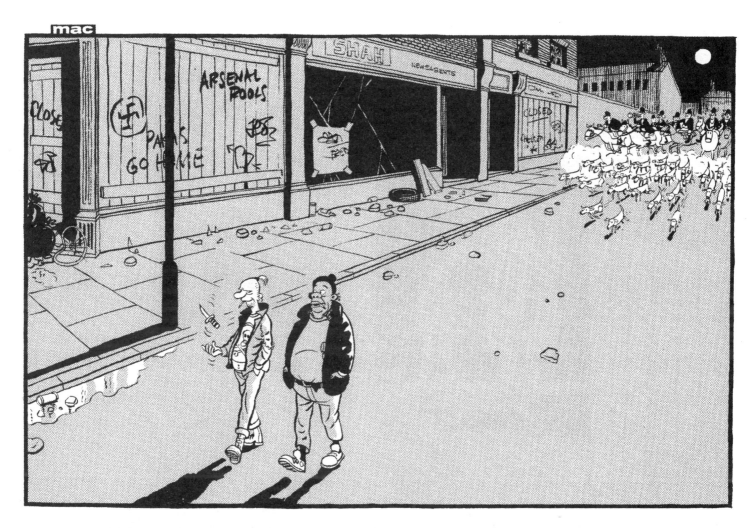

'Makes you laugh, don't it? How do that bunch of plonkers in the Government think they're goin' to reduce street crime?' *21 March 2002*

In his Budget, Chancellor Gordon Brown announced the biggest increase in public spending in 30 years, funded by the equivalent of a 4p rise in income tax. Meanwhile, new detention laws for 12- to 16-year-olds were introduced to combat soaring street crime.

'You'll be lucky. Gordon Brown got here first.' *18 April 2002*

Following the publication of a Treasury report on the NHS by Derek Wanless, it was revealed that the main beneficiary of the Chancellor's spending spree would be the Health Service which would receive billions of pounds a year in extra funding.

'Right, team. One more toasht to Gordon Brown, then out with thish young lady's appendix – or is it bresht implants we're doing?' *19 April 2002*

The 59-year-old lead singer of the Rolling Stones, Mick Jagger – as famous for his hedonistic lifestyle as for his music – was knighted in the Queen's Birthday Honours on the personal recommendation of Prime Minister Tony Blair.

'Mick's so pleased, he's making a donation to the Labour Party – us!' *11 June 2002*

The Prime Minister's wife, Cherie Blair, sparked a diplomatic row when she appeared to sympathise with Palestinian suicide-bombers in a speech made at the launch of a charity appeal on the day when a bus was blown up in Jerusalem, killing 19 Israelis.

'Hello. Looks like there's been another reshuffle.' *20 June 2002*

The all-party House of Commons Public Accounts Committee proposed scrapping the Royal Train – which costs taxpayers £703,000 a year and was only used for 15 journeys in 2001 – thereby ending 160 years of privileged rail travel for the monarchy.

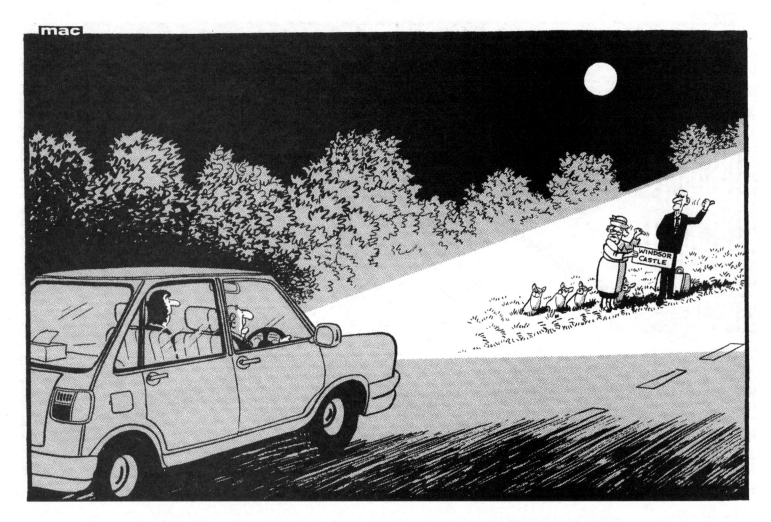

'*Now* what has New Labour done? First they scrap *Britannia*, then the Royal Train...' *8 July 2002*

While on holiday in the USA Tory Party Chairman David Davis was given the sack by new leader
Iain Duncan Smith. His new job was to shadow Labour's Deputy Prime Minister John Prescott.

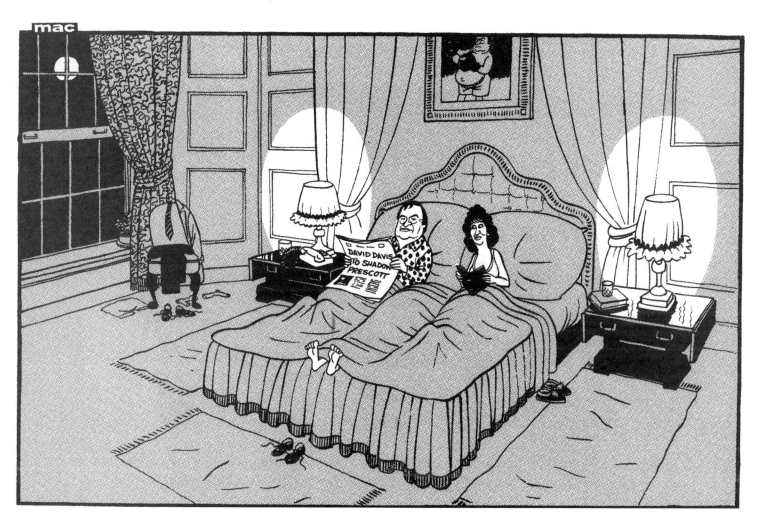

'John, dear. When does this Davis bloke start his new job?' *29 July 2002*

In what was seen as the first test of his party's new commitment to tolerance, Tory front-bench spokesman on foreign affairs, Alan Duncan, became the first Conservative MP ever to openly declare himself to be gay.

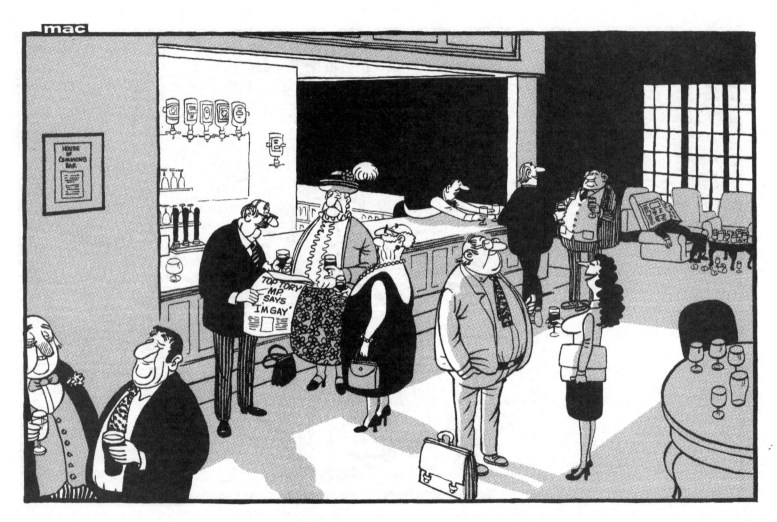

'I don't know about you chaps, but I'm surprised. I can usually spot one a mile off.'
30 July 2002

The publication of the diaries of former Tory Health Minister Edwina Currie revealed that she had had a four-year affair with cricket-loving future Prime Minister John Major when she was a backbencher in the 1980s.

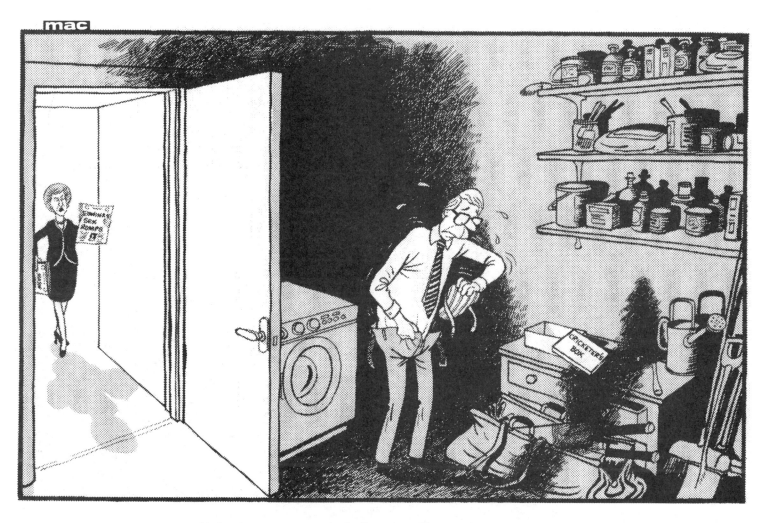

'John, have you seen today's papers?' *30 September 2002*

One of the proposals made at the Conservative Party conference in Bournemouth was to expand the 'right to buy' scheme for council tenants, introduced in the 1980s, to include the million or so people who currently live in housing-association properties.

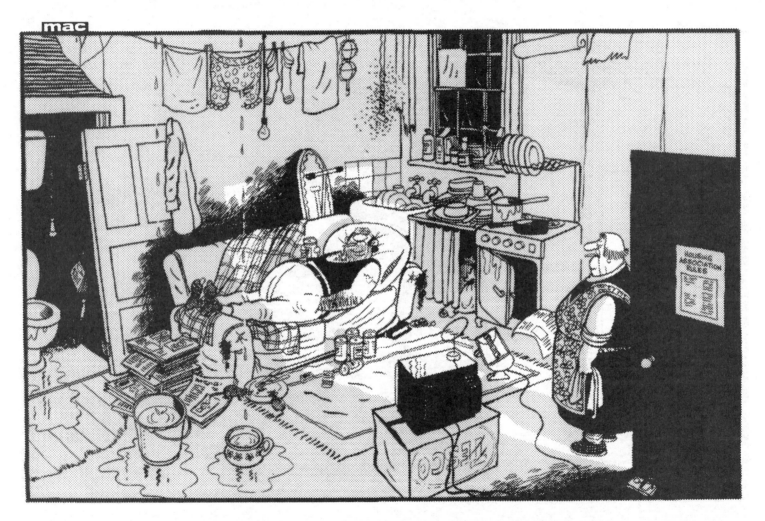

'Fantastic news. If the Tories get in we can buy this place.' *10 October 2002*

Lord Irvine, the millionaire Lord Chancellor – who had been criticised in 1998 over the huge cost of the wallpaper used to refurbish his official residence – hit the headlines again when he was forced to decline a bumper 12.6% (£22,700) pay rise.

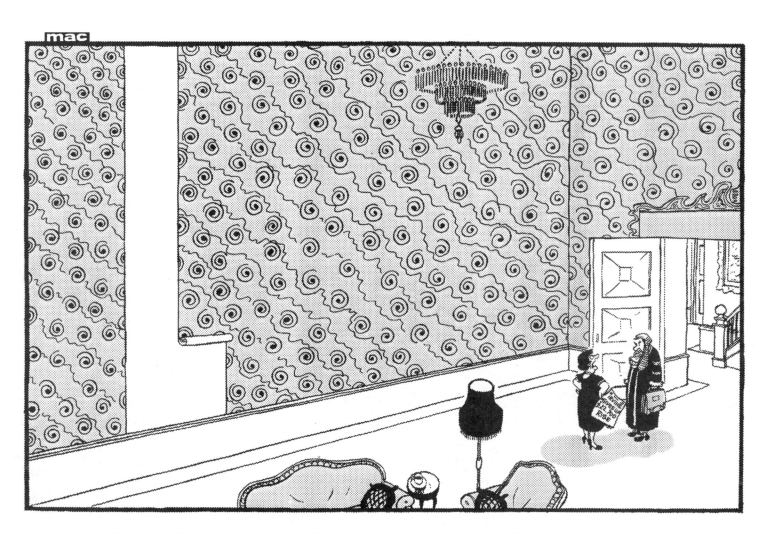

'You idiot! We could have bought that last roll of wallpaper we need!' *10 February 2003*

Defence Secretary Geoff Hoon was criticised for taking his family skiing in the French Alps at a time when 40,000 British troops prepared to go to war with Iraq amid complaints of inadequate supplies, including a shortage of toilet paper.

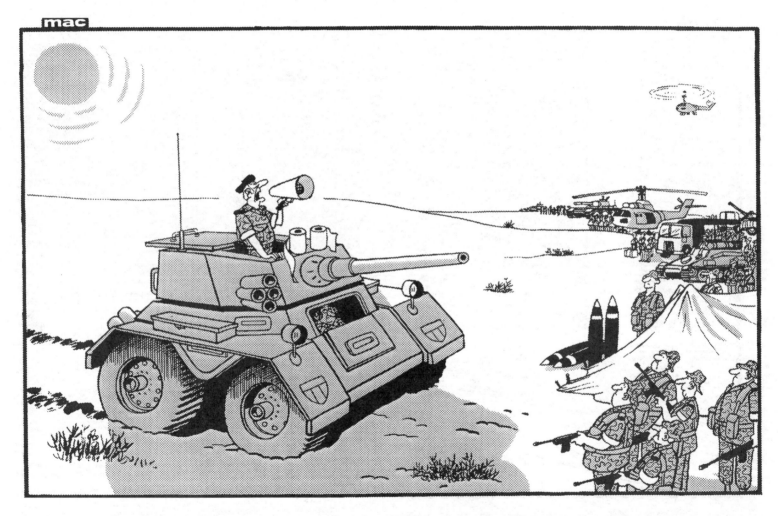

'Stirring news, men. At great risk to himself, and to help us here in the Gulf, our Defence Secretary has single-handedly stolen two toilet rolls from his hotel in the French Alps...' *24 February 2003*

Splits appeared in the Cabinet over the prospect of Britain and the USA attacking Iraq without UN backing. International Development Secretary Clare Short threatened to resign over the issue and accused the Prime Minister of being 'reckless'.

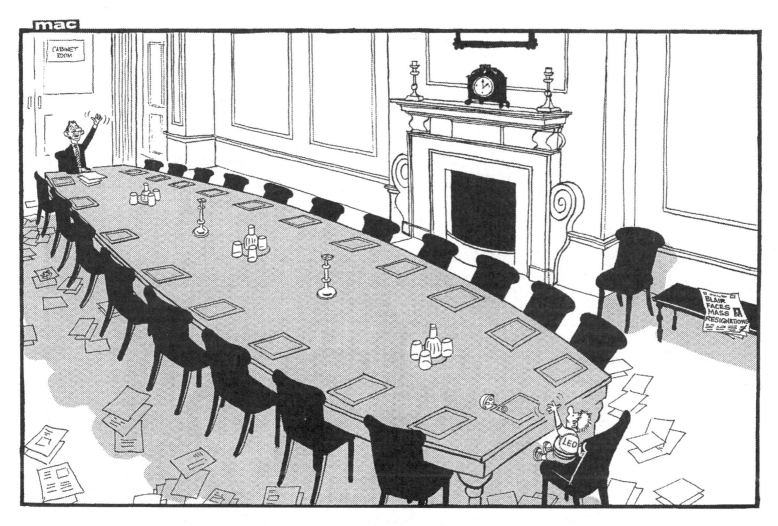

'Right. Hands up those who think the nasty man should be given a smacked bottom so everyone else can live happily ever after...Good, that's fairly conclusive. The ayes have it.' *10 March 2003*

Former Welsh Secretary Ron Davies, who had lost his Cabinet post after a gay sex encounter in London in 1998, resigned from the Welsh Assembly after being spotted near a notorious gay haunt off the M4. He claimed he had been looking for badgers.

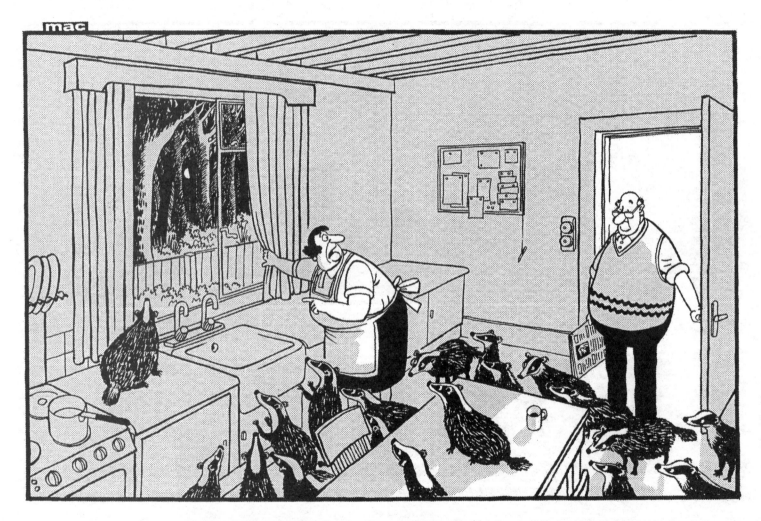

'I had to let them in. Ron Davies is out there looking for badgers.' *11 March 2003*

Tony Blair returned to face a rebellious House of Commons after attending a summit in the Azores at which US President Bush declared that a 'moment of truth' had arrived over war with Iraq.

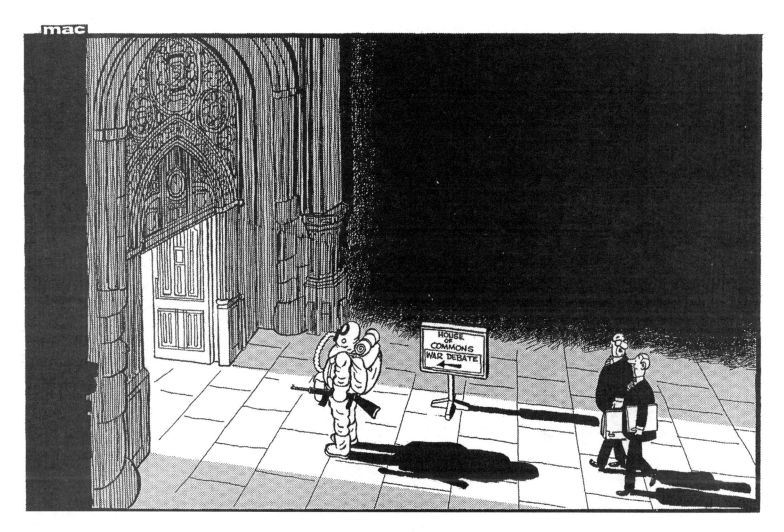

'It's the Prime Minister's moment of truth – you have to admire his bravery.' *18 March 2003*

Having resigned with considerable dignity over war with Iraq, former Leader of the House of Commons Robin Cook lost popular support when he called for British troops to be brought home. He later retracted his statement in a radio interview.

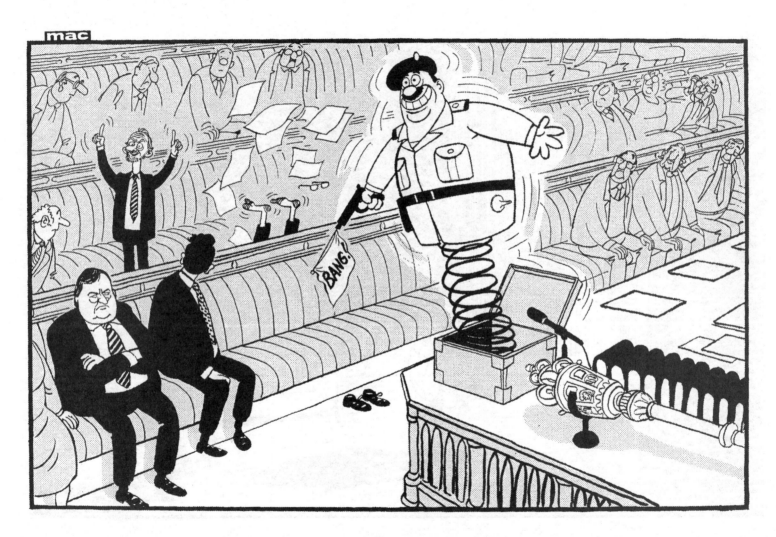

'All together now, when he comes round – April Fool!' *1 April 2003*

The Allied ground assault on Baghdad began after days of relentless aerial bombardment. Meanwhile, Science Minister and supermarket millionaire Lord Sainsbury donated a further £2.5 million to the Labour Party.

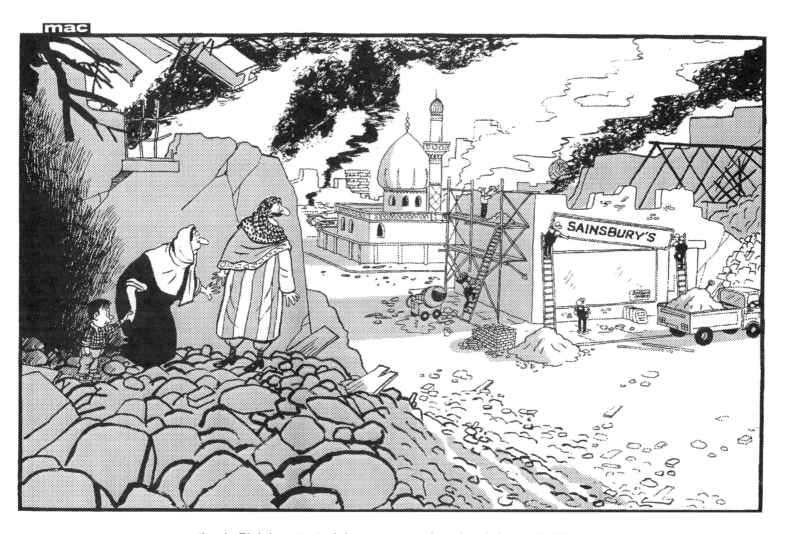

'Look. Blair has started the reconstruction already.' *3 April 2003*

There was widespread concern for Britain's sovereignty when the Government announced that there would be no national referendum on a new European constitution drafted by former French President Valery Giscard d'Estaing.

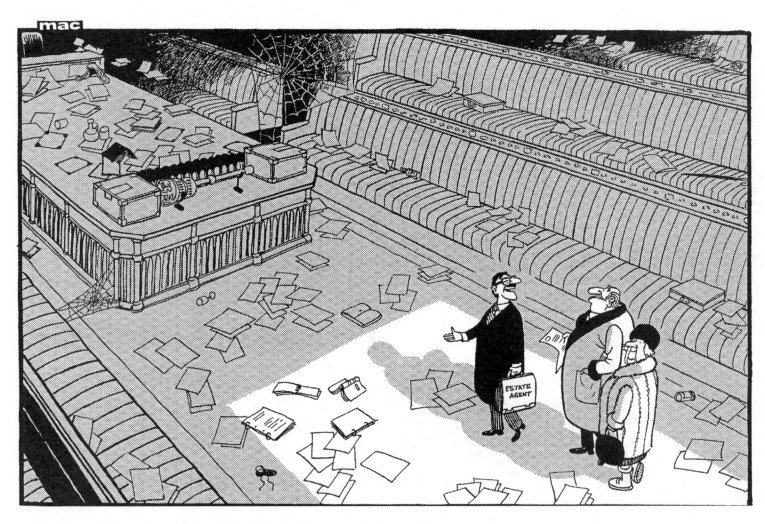

'In its day it was quite an important place, I believe. But the chap in charge handed everything over to new managers in Brussels.' *20 May 2003*

The position of Tony Blair's chief spin doctor Alastair Campbell seemed to be in jeopardy after allegations were made by a BBC correspondent that he had 'sexed up' intelligence reports in order to get the British public behind the war with Iraq.

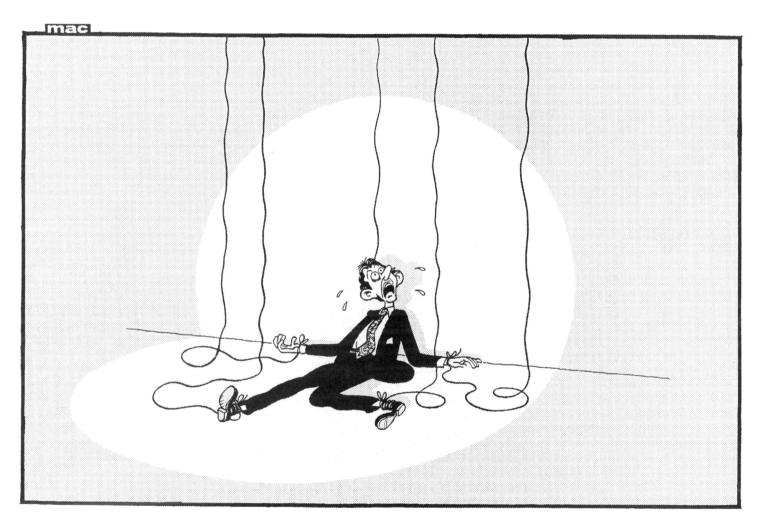

'Are you still there?...don't go Alastair...please, Alastair...ALASTAIR!' *30 June 2003*

Former Downing Street guru, Carole Caplin – whose naked showers with Cherie Blair and relationship with property dealer Peter Foster hit the headlines – was rumoured to be writing a book about her 11 years at No.10 which could earn her £1 million.

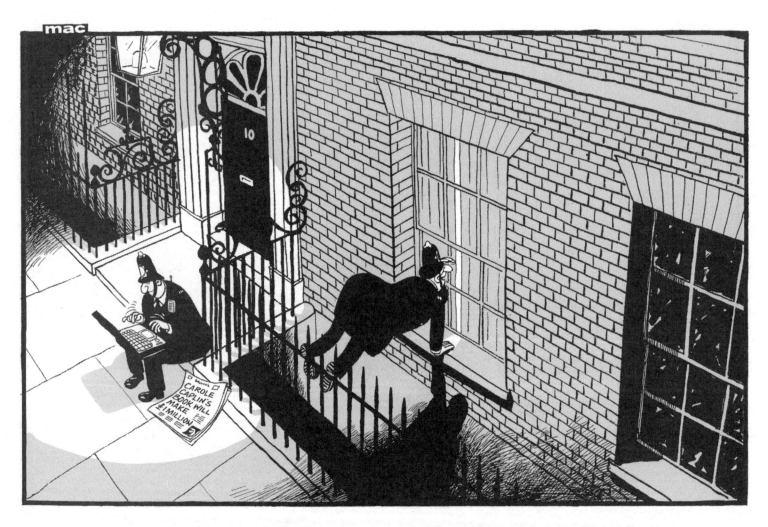

'...Suddenly her warm body is beside him. With pulses racing she pushes his despatch box to one side then, leaning forward provocatively, she breathes softly in his ear: "Leo's wet the bed again." ' *16 September 2003*

At the annual Labour Party conference in Bournemouth, Prime Minister Tony Blair faced mass rebellions by rank-and-file activists over Britain's involvement with the war in Iraq, and rumours of a potential leadership challenge by Chancellor Gordon Brown.

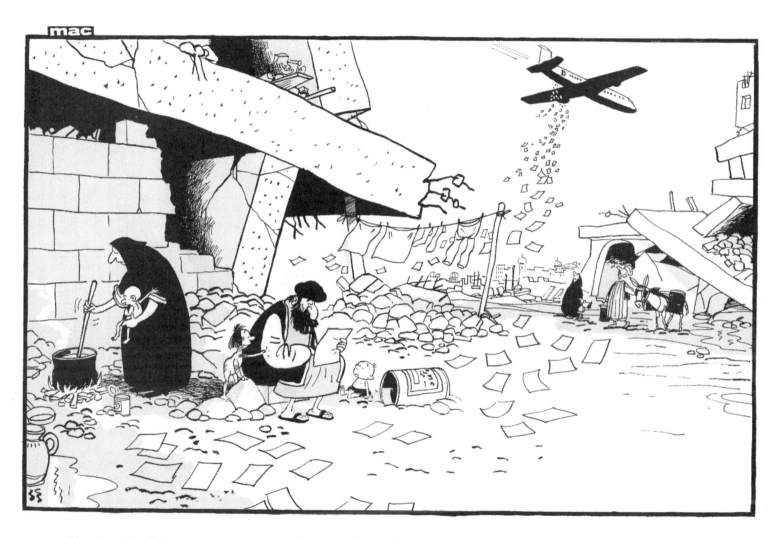

'No electricity? Unable to watch television? GREAT NEWS! We will be dropping leaflets daily bringing you all the latest from the Labour Party conference in Bournemouth...' *30 September 2003*

As Tony Blair faced down his critics, a Channel 4 drama-documentary, *The Deal*, alleged that in 1994 he and Gordon Brown had met in the Granita restaurant in Islington and agreed that Brown would succeed him as Prime Minister if Labour came to power.

New Deal *1 October 2003*

An official Audit Commission report blamed Deputy Prime Minister John Prescott for the recent huge rise in Council Tax charges. Meanwhile, in Germany a 42-year-old self-confessed cannibal went on trial.

'I hope you're hungry. Daddy's invited John Prescott for dinner.' *5 December 2003*

In his New Year message, Tony Blair dealt Chancellor Gordon Brown's leadership ambitions a major blow when he indicated that he intended to remain in Downing Street until 2010.

'Thanks for your card, Mr Blair...not much news here. It's raining, Mrs Wilkins the cleaner has a cold...and oh, yes, Gordon Brown has staged a *coup d'état*.' *2 January 2004*

Defence Secretary Geoff Hoon's position was in doubt on the eve of the publication of the Hutton Report on the death of weapons expert, Dr David Kelly. Meanwhile, Transport Secretary Alistair Darling announced a major review of Britain's ailing railways.

'Psst. Isn't that Geoff Hoon?' *20 January 2004*

At a Downing Street reception for the homeless charity, Centrepoint, Cherie Blair claimed that the Prime Minister had once slept on a park bench near London's Euston station in his gap year before going to Oxford University.

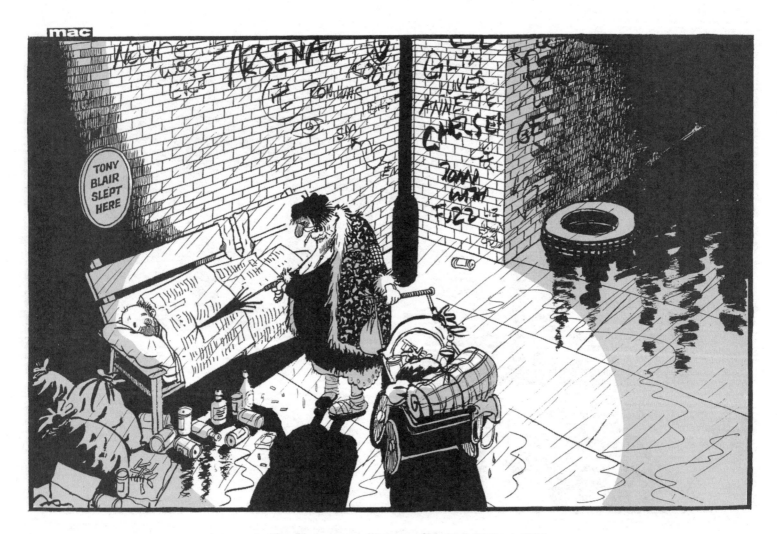

'Oy. Shove over. It's me – Cherie.' *2 March 2004*

After being unexpectedly absent from the Budget debate in the House of Commons because of a 'violent stomach bug', Liberal Democrat leader Charles Kennedy appeared at his party's annual conference in Southport looking extremely unwell.

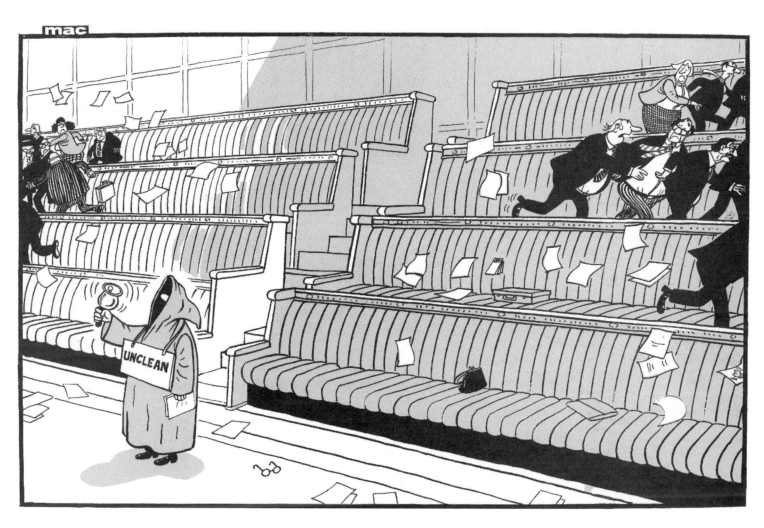

'Well, I think Charles Kennedy should take a few days off.' *23 March 2004*

As the Prime Minister prepared to send in more British troops to Iraq, 52 of Britain's most distinguished former ambassadors and high commissioners wrote him a letter urging him to stop his support for the foreign policy of US President Bush.

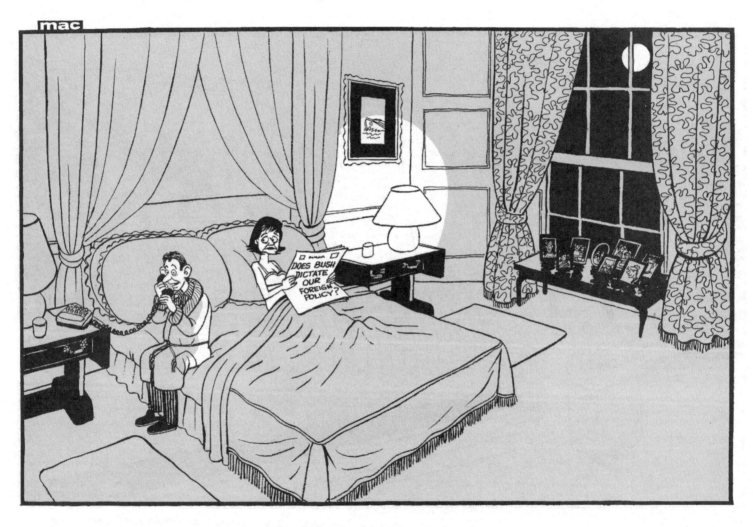

'3000 of our troops to Iraq? Of course, George...Er, George, can I tell everybody it's my decision? ...PLEEEESE, George.' *28 April 2004*

Daily Mirror photos allegedly showing British troops abusing Iraqi prisoners were later proved to be fakes. Meanwhile, as local elections began in Britain, a poll revealed that Tony Blair and new Conservative Party Leader Michael Howard were neck and neck.

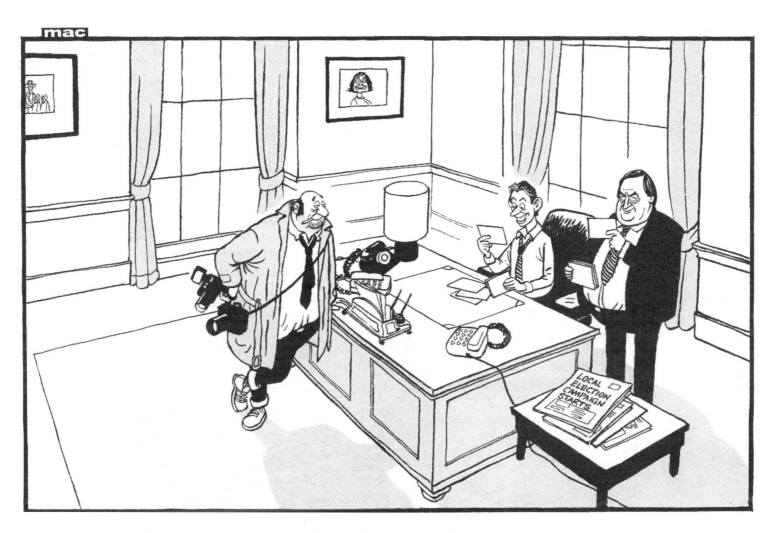

'These fake photos are sensational! Michael Howard beating up asylum-seekers and torturing pensioners – how much?' *5 May 2004*

Only months after a new £600,000 glass security screen had been fitted to the public gallery of the House of Commons, two protesters for fathers' rights threw condoms filled with purple flour at Tony Blair during *Prime Minister's Question Time*.

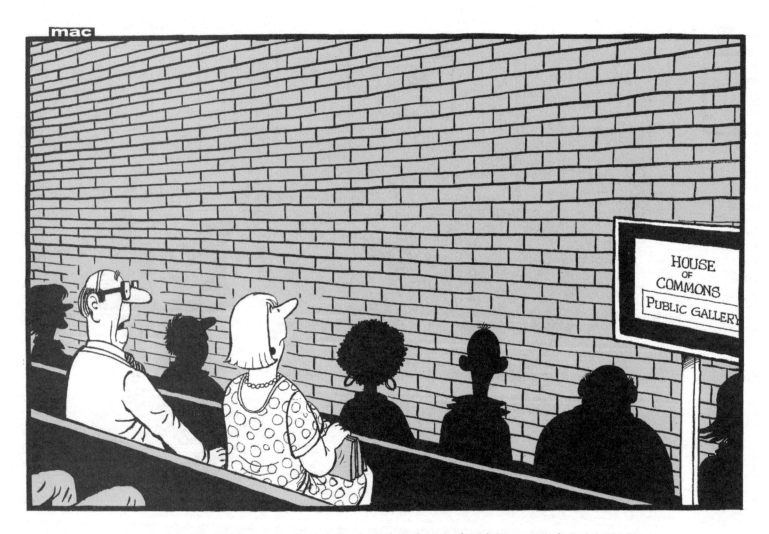

'I thought it was bad enough when they put up the glass screen.' *20 May 2004*

Nearly 25,000 British war veterans and their families flocked to Normandy for the official celebrations marking the 60th anniversary of the D-Day landings. Meanwhile, back home, campaigning for the European elections began in earnest.

'Oh really? And what kind of bloke slopes off to France to enjoy himself, leaving a good-looking woman like you behind?' *8 June 2004*

Chancellor Gordon Brown announced plans to axe 104,000 civil service jobs in Britain to cut public spending. Meanwhile, security was tightened in Westminster when an MI5 report suggested that Big Ben could be a target for terrorists.

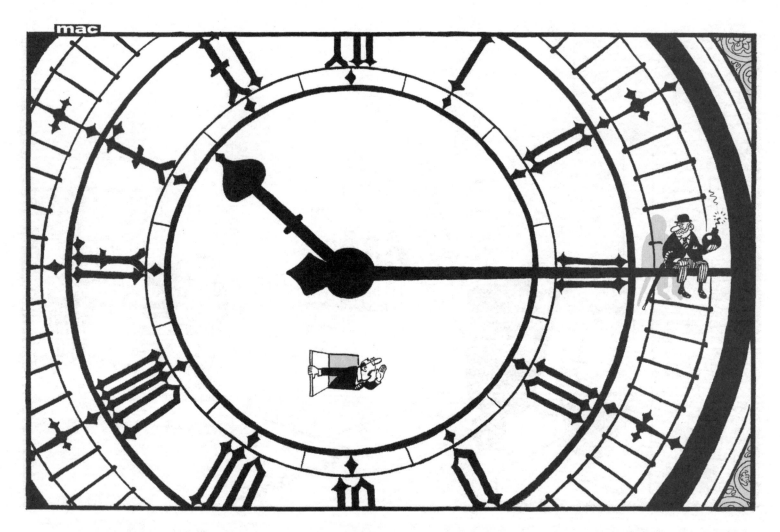

'All right, Farqueson. Gordon Brown says leave Big Ben in one piece and you can have your job back.' *14 July 2004*

Local Government Minister Nick Raynsford announced a shake-up in the Council Tax system that would effectively treble the cost for some householders. Meanwhile, the Home Secretary revealed a five-year plan to crack down on street crime.

'Mr Blunkett has ordered us to crack down on crimes like daylight robbery – a man is helping with our inquiries.'

20 July 2004

It was revealed that the Home Secretary, David Blunkett, had a close friendship with 42-year-old American Kimberly Fortier, chief executive of the *Spectator* and a married mother.

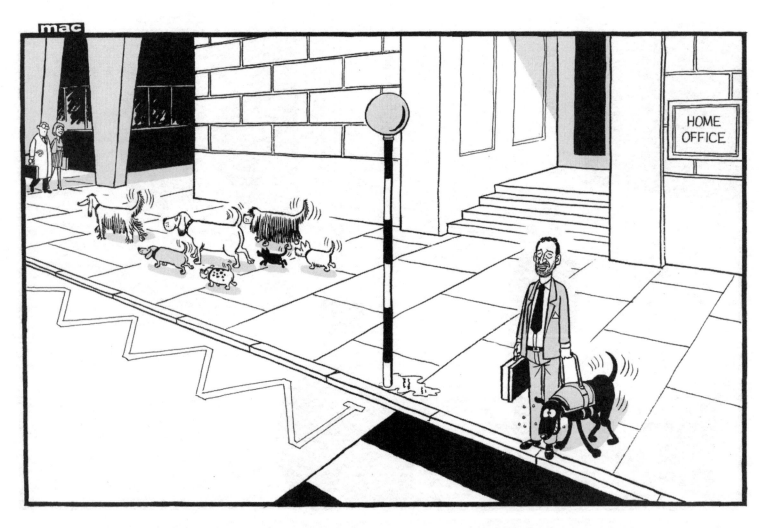

'Everyone's entitled to a little bit of love in their lives – what d'you think, Sophie?'
17 August 2004

While on holiday in Wales, Deputy Prime Minister John Prescott rescued a semi-conscious man who had been thrown out of his kayak at a Canoe Centre in Snowdonia and was being swept towards a dangerous waterfall.

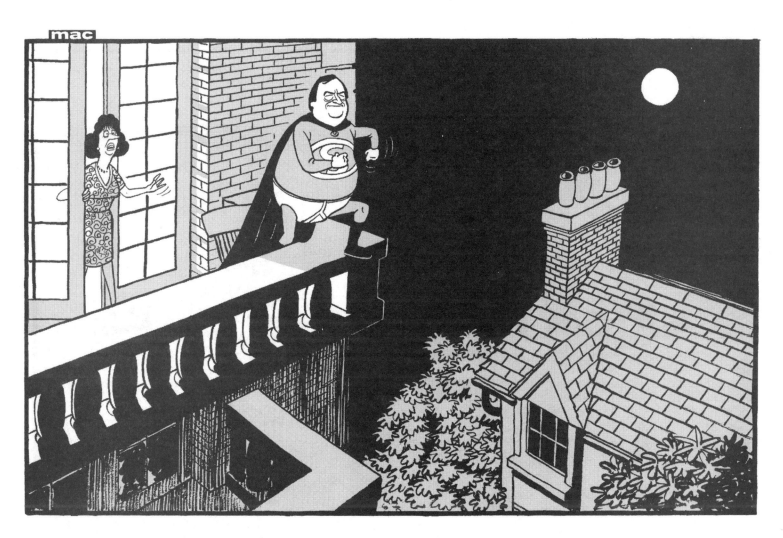

'Please, John. It's a long way. Why not just phone Tony to tell him about the rescue?' *18 August 2004*

Further security questions were raised when five pro-hunting demonstrators – including the son of pop star Bryan Ferry – stormed the House of Commons.

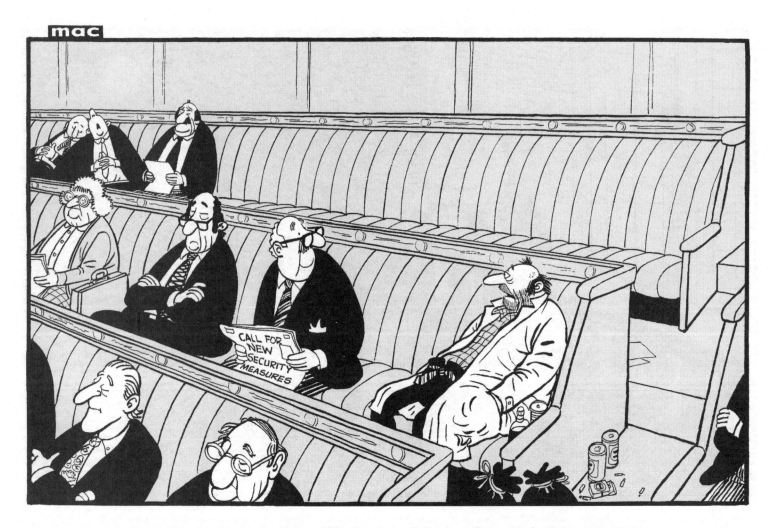

'Good lord, no. I'm not an MP – I've been living here for years.' *17 September 2004*

There was widespread criticism of the anti-social consequences of the Gambling Bill which could put a Las Vegas-style 'super casino' filled with big-money slot-machines in every British town, and earn the Treasury £260 million a year in tax revenue.

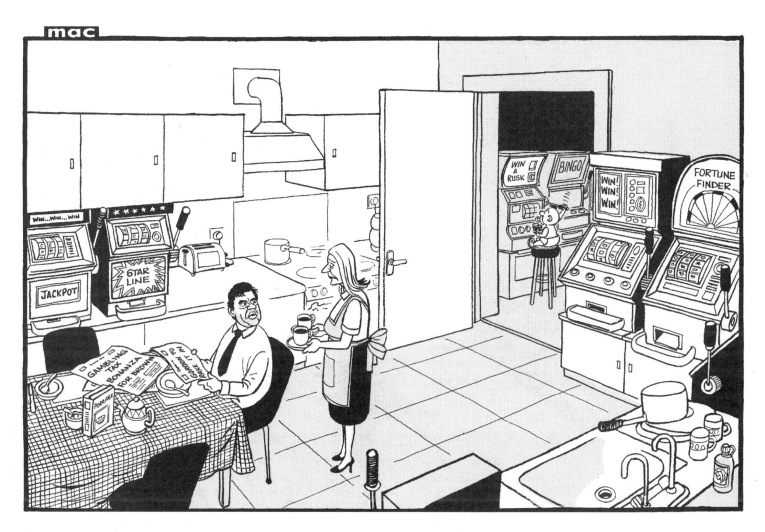

'More housekeeping money? Dammit, Sarah. I've only just forked out for a new kitchen.' *21 October 2004*

At a meeting of EU interior ministers in Luxembourg, Home Secretary David Blunkett agreed to sign away Britain's power to veto new European laws on immigration and asylum but insisted that this would not affect UK border controls.

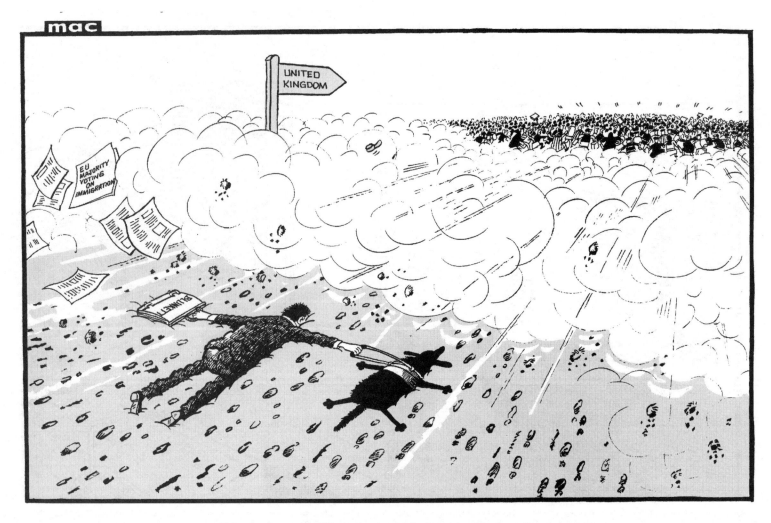

'Of course we'll still retain control of our bord...' *26 October 2004*

Tony Blair was accused of fuelling the politics of fear when he announced the introduction of further national security measures including the formation of a 5000-strong British version of the FBI to be called the Serious Organised Crime Agency (SOCA).

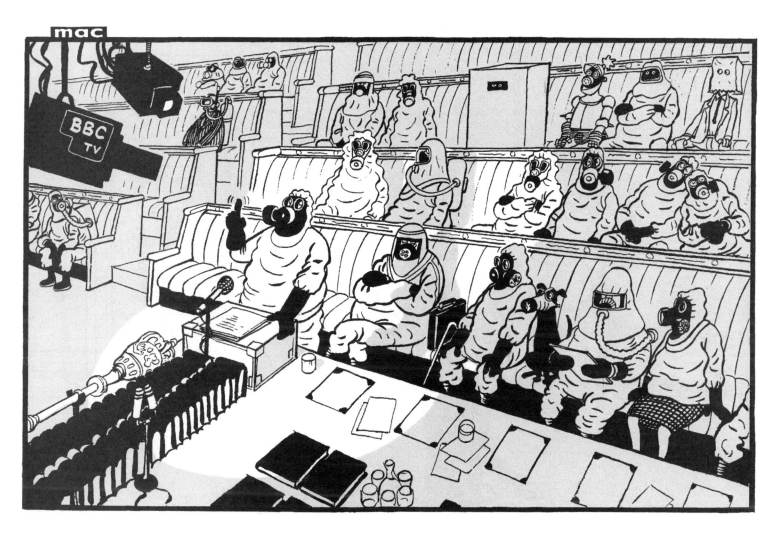

'...Furthermore this Government has been accused of creating a climate of fear...what nonsense. Who would stoop so low?' *25 November 2004*

Less than a month after quitting the UK Independence Party, 62-year-old former TV presenter Robert Kilroy-Silk launched his new political party, Veritas, with an attack on multiculturalism in Britain.

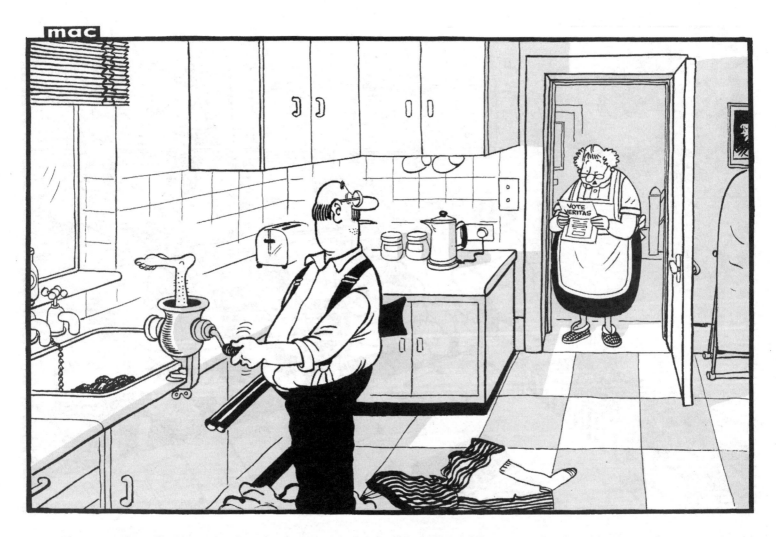

'Hang on, dear. That wasn't a burglar. It was somebody called Kilroy-Silk canvassing for a new party.' *3 February 2005*

As the election debate gathered momentum, Tory Party leader Michael Howard attacked Labour's 'total failure' to deal with immigration and pledged to set up a Border Control Police Force accountable to a new Minister of Homeland Security.

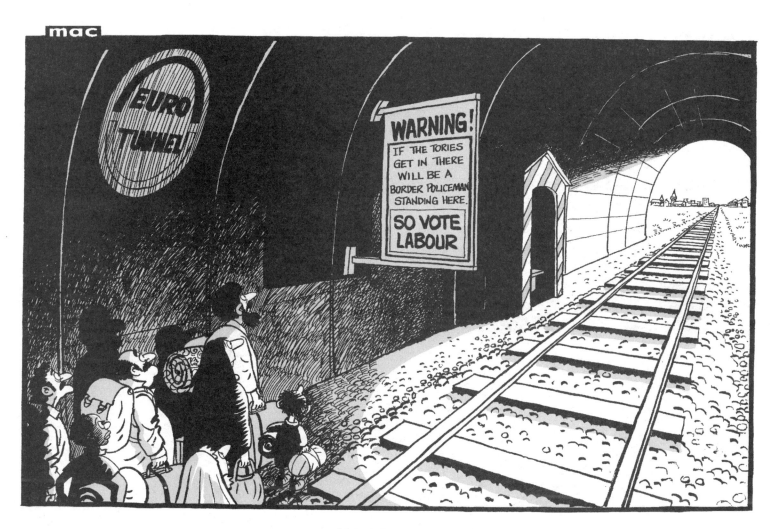

30 March 2005

After hearing evidence against six Birmingham councillors who rigged postal votes in 2004's local elections, a High Court judge condemned the Government's failure to implement new measures to tackle similar fraud ahead of the General Election.

'Okay, if there's nobody in there waiting to alter the postal votes, why the regular chicken and chips?' *6 April 2005*

As election fever mounted, Liberal Democrat leader Charles Kennedy and his wife, Sarah, showed off their first baby, Donald James, who was born at St Thomas' Hospital, London.

'Oh, no! He's been canvassing on behalf of his dad already!' *13 April 2005*

In a speech to launch the Labour Party's new manifesto Tony Blair confounded Gordon Brown's supporters by declaring that he intended to serve for a full third term if re-elected. Meanwhile, new research showed that aspirin could stave off heart-attacks.

'Yes, folks. I will be serving another full-term as Prime Minister.' *14 April 2005*

As the crisis in Britain's hospitals deepened, Labour leaders claimed that Conservative election plans for the Health Service would result in patients paying huge sums for treatment and threaten the very existence of the NHS itself.

'Remember, folks. Voting for the Conservatives would mean an end to the NHS as we know it.' *19 April 2005*

After the leaking of the Attorney-General's report on the legality of the invasion of Iraq, Tony Blair and Labour leaders were accused of lying to the British people over the reasons for going to war, a claim they denied strenuously.

'Good morning, young lady. I'm so pleased to meet you in your beautiful home and hey! What a lovely little doggy...' *28 April 2005*

Researchers from Oxford University's Department of Physiology reported that junk-food diets were linked to aggressive behaviour and learning difficulties in children. Meanwhile, political campaigning intensified as the General Election approached.

'Answer the door, son – but don't bite anybody from Labour. It makes you aggressive.' *3 May 2005*

At the Conservative Party conference in Blackpool reference was made to an 82-year-old man who had been forcibly evicted from Labour's conference for crying 'nonsense' during Jack Straw's speech justifying the continued presence of British troops in Iraq.

'..and rest assured, our security team will not be giving hecklers here the same appalling treatment as that dished out at Labour's conference.' *4 October 2005*

As Tory leadership hopefuls David Davis, Kenneth Clarke, Liam Fox and David Cameron made speeches to the Conservative Party conference, the *Daily Mail* serialised the memoirs of Sharon Osbourne, star of TV's pop-talent show *The X-Factor*.

'Psst. Ask Sharon Osbourne who's winning so far.' *6 October 2005*

In a major challenge to Tony Blair's authority, the Terrorism Bill – allowing police to hold terror suspects for 90 days without charge – was defeated in the House of Commons despite Chancellor Gordon Brown being flown back from Tel Aviv to vote.

'This is your captain speaking. Fasten your seatbelt, please, we are approaching Tel Aviv airport yet again...' *10 November 2005*

The new Licensing Act – which would enable 700 pubs, clubs and supermarkets to be granted licences to serve alcohol up to 24 hours a day – was passed in the House of Commons by 302 votes to 228.

'We losht the vote on binge-drinking.' *16 November 2005*

When her City lawyer husband David Mills was arrested to face charges of bribery and corruption brought by Italian police, Culture Secretary Tessa Jowell denied all knowledge of his devious financial affairs.

'From now on, David, we'll have to be more open with each other...now, is there anything else you haven't told me?'

3 March 2006

Home Secretary Charles Clarke launched an official inquiry following allegations that Britain's top policeman, Metropolitan Police Commissioner Sir Ian Blair, had secretly tape-recorded a phone conversation he had had with Attorney-General Lord Goldsmith.

'Ah, Home Secretary...testing, testing...one, two, three, four...Monday, Tuesday, Wednesday. I believe you wanted to see me...' *14 March 2006*

Shortly after Britain's biggest ever cash robbery – from a Securitas depot in Kent –
£15 million of the stolen money was found dumped in a van parked near the Channel Tunnel.
Meanwhile, the 'cash for honours' scandal continued to hit the headlines as more details emerged.

' "Sorry lads," says Fingers, "we're going to 'ave to dump some of the fifty-three million
quid we nicked from Securitas." So I rings up Tony...' *17 March 2006*

Under increasing pressure over the 'cash for honours' row, Tony Blair released the names of 12 millionaires who had made secret loans to the Labour Party. Furious at this breach of confidentiality, many of them threatened to ask for their money back.

'Are there any other debts you haven't mentioned, Tony? The bailiffs have been in.'
22 March 2006

Two years after hitting the headlines for his involvement in a high-profile love-affair, Conservative Party higher education spokesman and former *Spectator* editor, Boris Johnson, father of four, was accused of having a second extramarital relationship.

'You're strangely quiet tonight, Boris darling – have you told your wife yet?' *4 April 2006*

As the Government admitted it had no idea how many illegal immigrants were living in Britain, Communities Secretary Ruth Kelly determined to push through Labour's massive new house-building programme in southern England despite widespread opposition.

'Actually we haven't reached Britain yet, Miss Kelly. But we'd like granite worktops and white tiles in the kitchen...' *11 May 2006*

Soon after taking over as Home Secretary John Reid attacked his own department, saying it was 'not fit for the purpose'. Meanwhile, new Tory leader David Cameron spoke at a conference about the limitations of work, emphasising the importance of 'quality of life'.

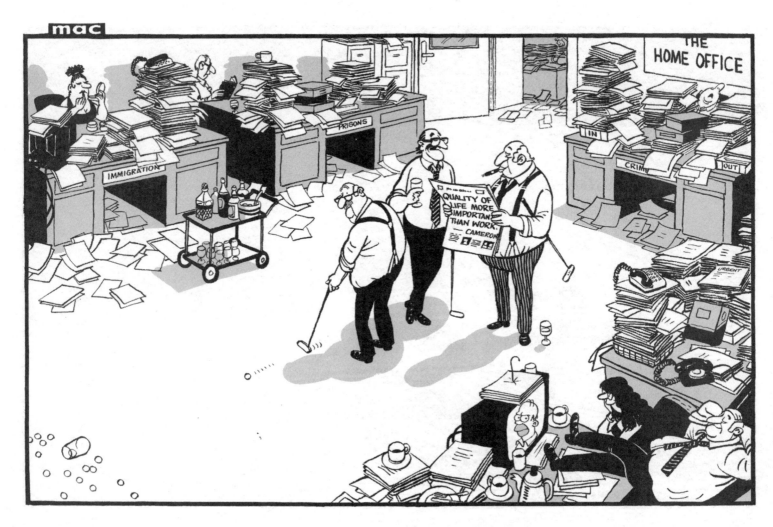

'Cameron's not saying anything new – we've known that for years.' *24 May 2006*

The two most prominent judges in Britain – former Lord Chief Justice Lord Woolf and his successor Lord Phillips – launched an unprecedented attack on the Government and its policy on crime and sentencing.

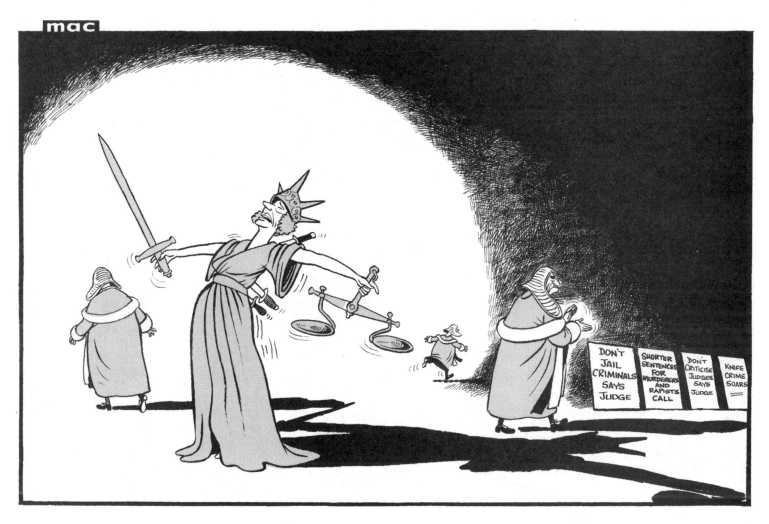

1 June 2006

Deputy Prime Minister John Prescott lost his grace-and-favour mansion, Dorneywood in Buckinghamshire (but kept his flat in London), after being photographed playing croquet there when he was supposed to be running the country in Tony Blair's absence.

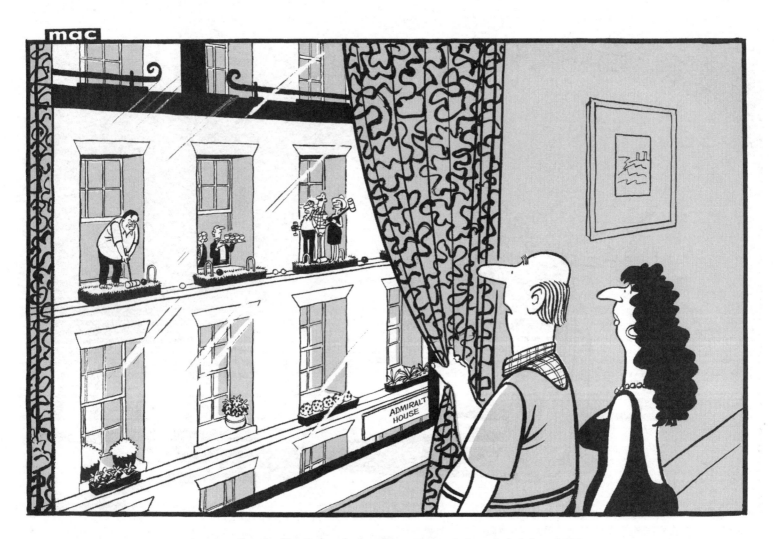

'Looks like he's missing Dorneywood already.' *2 June 2006*

There were more accusations of sleaze when it was discovered that Deputy Prime Minister John Prescott had accepted hospitality at the Colorado ranch of an American billionaire who was bidding to run a supercasino in London's Millennium Dome.

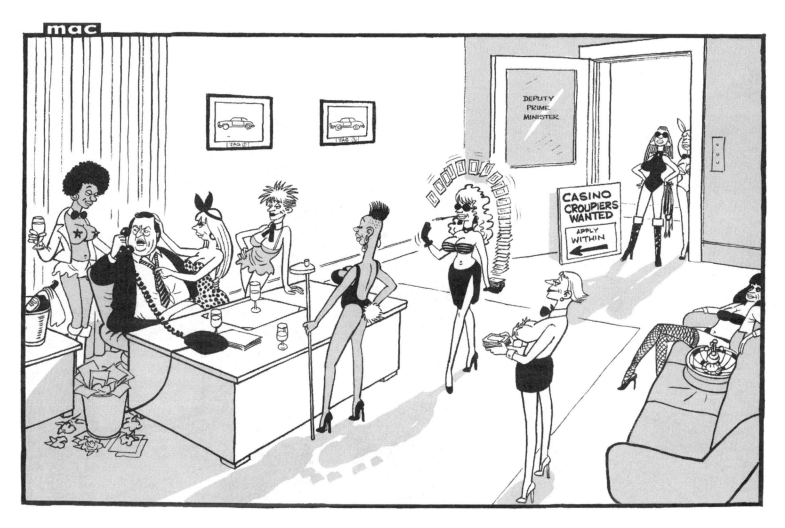

'For the last time, I'm not resigning! I have a very busy job and I intend to get on with it!' *7 July 2006*

In a move that surprised and angered many, Conservative Party Leader David Cameron called on the public to show more love and understanding to the 'hoodie' teenage yobs responsible for the epidemic of antisocial behaviour on Britain's streets.

'What are the police doing about it? Streets full of Tory women trying to give us love and compassion. We're frightened to go out at night.' *11 July 2006*

Speaking at a private meeting with Muslim Labour MPs and those with large Muslim constituencies, Deputy Prime Minister John Prescott allegedly described President Bush's Middle East policy as 'crap'.

'Back again, Mr Prescott? How can I help you this time?' *18 August 2006*

An article in *BBC History Magazine* said that Margaret Thatcher had been Britain's most effective prime minister over the past 100 years. Meanwhile, a Harley Street doctor claimed that he had discovered an 'eternal youth' drug based on human growth hormones.

'...and I'm on the new "eternal youth" drug – you've got five minutes to pack!'
30 August 2006

MPs were reluctant to back Tony Blair's bid to replace Britain's nuclear taskforce with a new generation of Trident submarines but had no difficulty in supporting a move to increase their salaries to an average of £100,000 a year, a 66% increase.

'Personally, I say to hell with Trident. We should spend the money keeping this trough filled.' *5 December 2006*

During the preparation for a retrospective of the work of the artist Euan Uglow it was revealed that Cherie Blair had posed, half-naked, for his painting entitled *Striding Nude, Blue Dress* in 1978 when she was a 24-year-old law student.

'Are you sending any personal Christmas cards to your barrister friends this year, Cherie?' *12 December 2006*

The 'cash-for-peerages' case took a new turn when Tony Blair himself was questioned by police over four Labour Party lenders who had received seats in the House of Lords after being personally recommended by the Prime Minister.

'If we do meet the Blessed One, are you sure this'll be enough for a peerage each?'
19 December 2006

A report by the Commission for Social Care said that the Welfare State was no longer able to give free help to the frail and elderly. Meanwhile, the Home Office claimed it knew nothing of crimes committed by Britons abroad.

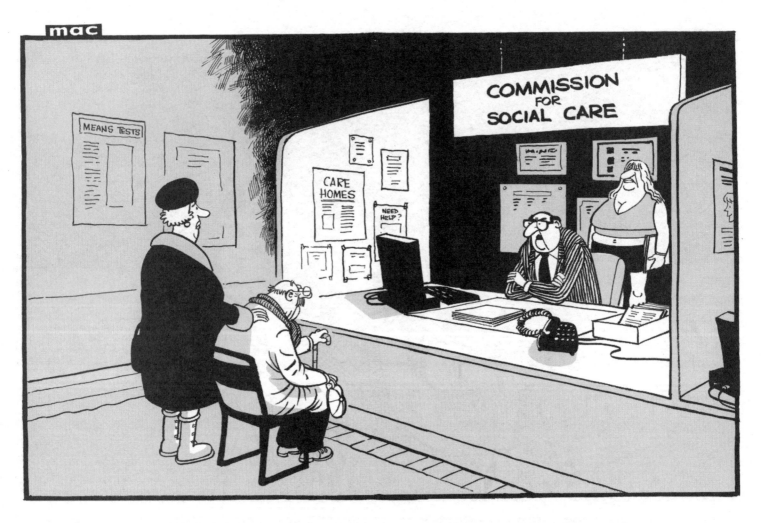

'Oh, come along! Lots of people are old, confused and can't remember anything, but they still go out to work at the Home Office.' *12 January 2007*

The *Daily Mail* began a campaign to lobby for the Government to provide drugs on the NHS to treat Alzheimer's Disease (which affects 400,000 in the UK) rather than spend it on marketing consultants and free heroin for junkies.

'There are times when I wish I could forget the last ten years under Tony Blair.'
28 February 2007

After the inquiry into the 'cash-for-peerages' scandal heard that Labour fundraiser Lord Levy, known as 'Lord Cashpoint', had tried to bully No.10's Director of Government Relations into changing her story, it seemed that he would soon be charged.

'I'm sorry, Lord Levy is out right now. I don't know when he'll be back.' *8 March 2007*

Tony Blair's new 'security, crime and justice' policy review, outlining his vision for the next decade, said that all schoolchildren should be monitored for criminal tendencies.

'I must warn you, Pickering. Tony Blair has decreed that all children are to be monitored for signs of criminal behaviour.' *28 March 2007*

On the 10th anniversary of the General Election which swept Tony Blair to power, the Prime Minister said that he would formally announce his resignation the following week and would officially endorse Gordon Brown as his successor.

2 May 2007

As Tony Blair prepared to leave No.10 many thought his wife's performance with *Strictly Come Dancing* star Anton du Beke at a charity ball left much to be desired.

'That's agreed then? A huge clap of thunder, a bolt of lightning, then written in the sky: "Behold my servant departeth on [the date], memoirs out soon priced £20." ' *8 May 2007*

The 2007 Wimbledon tennis tournament got off to a tense start as Britain's Naomi Cavaday narrowly failed to win two match points against 1997 champion Martina Hingis. Meanwhile, Tony Blair finally resigned as Prime Minister and was succeeded by Gordon Brown.

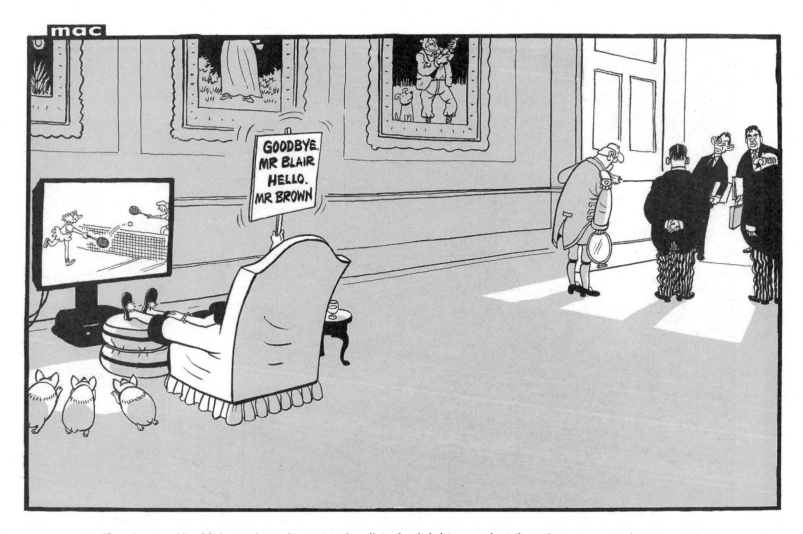

'Gentlemen. Her Majesty doesn't want to be disturbed right now...but there is a message.' *27 June 2007*

There was considerable speculation that the publication of *The Blair Years*, the diaries of former Labour Party spin-doctor Alistair Campbell, would shed new light on Tony Blair's behind-the-scenes manoeuvres to win the backing of MPs for the invasion of Iraq.

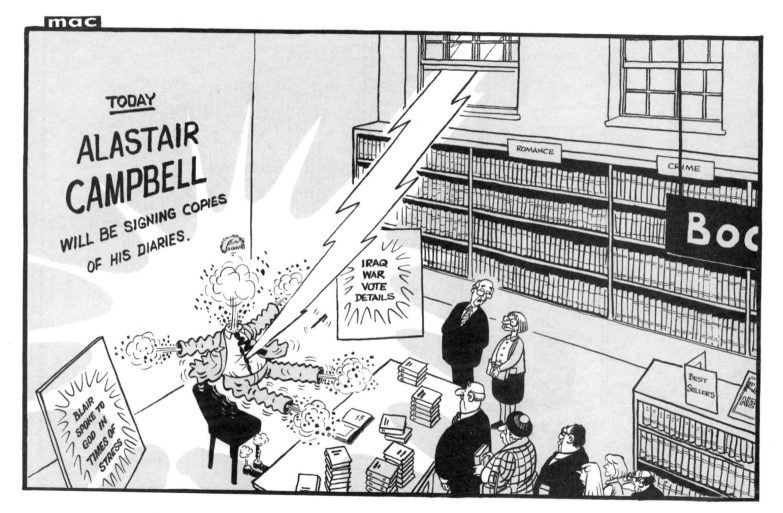

'Oh dear. Looks like Gordon Brown's been talking to God, too.' *10 July 2007*

As Labour's Ken Livingstone, well known for his love of newts, approached the end of his four-year period as Mayor of London, it was announced that the colourful MP for Henley, Boris Johnson, would stand against him as the official Tory candidate.

'There's a newt at the door canvassing for Ken Livingstone.' *17 July 2007*

A new poll conducted for *Channel 4 News* gave Labour an 11 point lead over the Conservatives, fuelling speculation that Gordon Brown would call an election in November.

'For heaven's sake, Gordon. Stop dithering and call an election. I want to know if I can unpack!' *27 September 2007*

Justice Secretary Jack Straw proposed an amendment to the Criminal Justice & Immigration Bill to allow citizens to use 'reasonable force' in self-defence against burglars and other criminals.

'You fool! The violence my husband is about to administer comes with the full authority of Jack Straw.' *28 September 2007*

Speaking at the Conservative Party conference in Blackpool, Shadow Chancellor George Osborne promised that a Tory government would revise the law on Inheritance Tax so that only estates worth more than £1 million would be liable.

'Sorry to have bothered you. We have persuaded Grandad not to go until the Tories get back in again.' *2 October 2007*

Leaked documents revealed that Home Secretary Jacqui Smith had sent secret memos to try and cover up a report by the Security Industry Authority that at least 5000 illegal immigrants had been cleared to work in sensitive Whitehall security jobs.

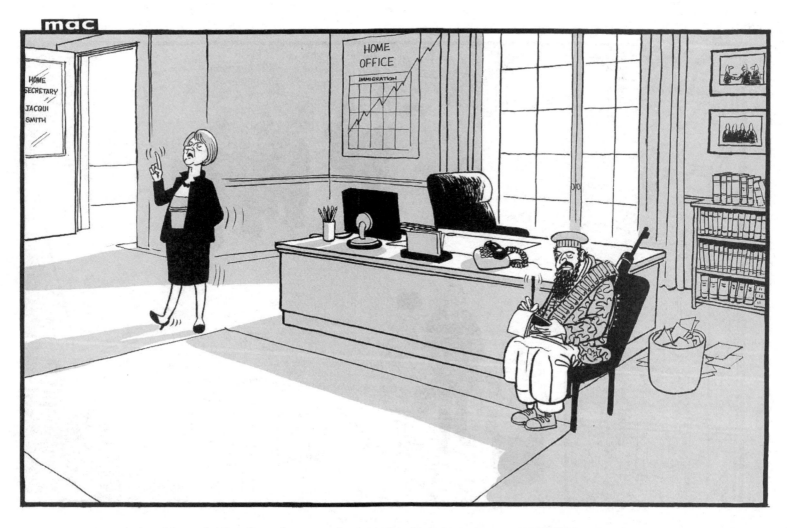

'Yes, mistakes have been made regarding illegal immigrants and jobs in security, but rest assured we are leaving no stone unturned...' *14 November 2007*

Labour's General Secretary Peter Watt resigned after admitting that he had known that multi-millionaire property tycoon David Abrahams had given the party nearly £400,000 in secret donations using middlemen.

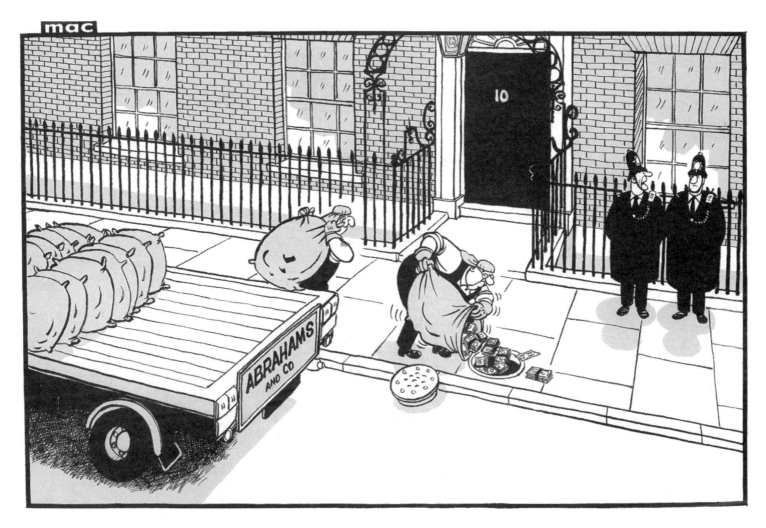

'No more secrecy about donations then.' *28 November 2007*

Sleaze allegations continued to dog Gordon Brown when it was revealed that Harriet Harman had accepted £5000 from David Abrahams to help fund her campaign to become Deputy Leader of the Labour Party.

'Oh. You're home early, Gordon, darling – how was your day?' *29 November 2007*

To help solve the problem of Britain's overcrowded prisons Lord Carter, the Government's adviser on the issue, proposed that fewer low-risk criminals should be jailed, advocating electronic tags and community service as an alternative.

'First they stopped us hanging people, then we were told not to jail anyone, then gradually we became superfluous.'

7 December 2007

After admitting that she did not feel safe walking the streets of London after dark, Home Secretary Jacqui Smith tried to make amends by saying that she had bought a kebab one evening in Peckham. It was later revealed that she had had a police escort.

'Please stop screaming, Home Secretary. The man in the shop is supposed to have a knife.' *22 January 2008*

A senior Tory MP was suspended after it was revealed that he had paid his 22-year-old son £45,000 of taxpayers' money, claiming that he was working as his father's parliamentary assistant, when in reality he was a student living in Newcastle.

'Has the man no shame? My parliamentary assistant is not in the family and earns every penny he gets... don't you, Archie?' *30 January 2008*

As the row over MPs' expenses continued, it was reported that a senior Muslim Labour MP had been bugged by police – a clear breach of parliamentary rules.

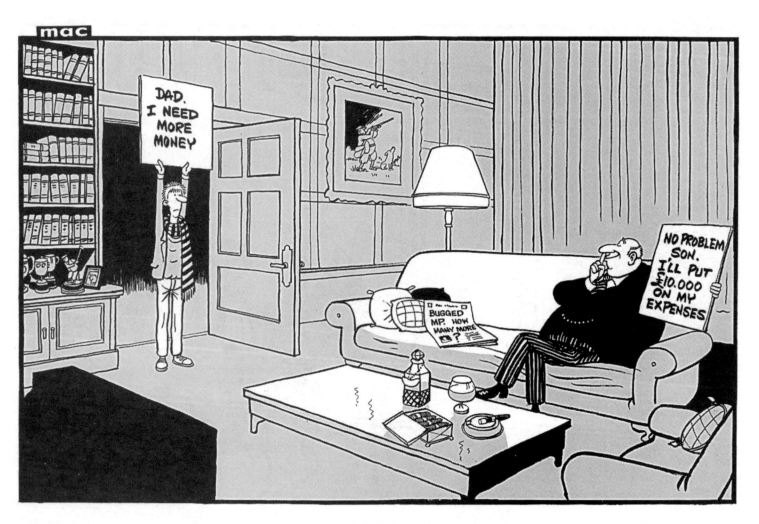

5 February 2008

The Government announced trials of a 'Find Your Talent' scheme in which schoolchildren would spend up to five hours a week in visits to theatres, galleries and museums. Meanwhile, police chiefs attacked the drinks industry for selling beer 'cheaper than water'.

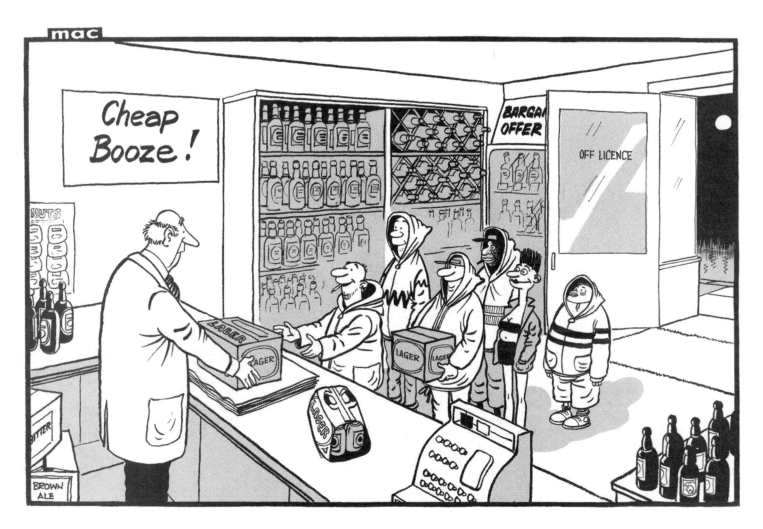

'That's right, mate. Theatres, museums, galleries and off-licences. All part of New Labour's five hours of culture initiative.' *15 February 2008*

As the Speaker of the House of Commons became the latest to face scrutiny over alleged false expenses claims, MPs debated awarding themselves a massive 33% pay-rise. Meanwhile, new research claimed that anti-depressants such as Prozac did not work.

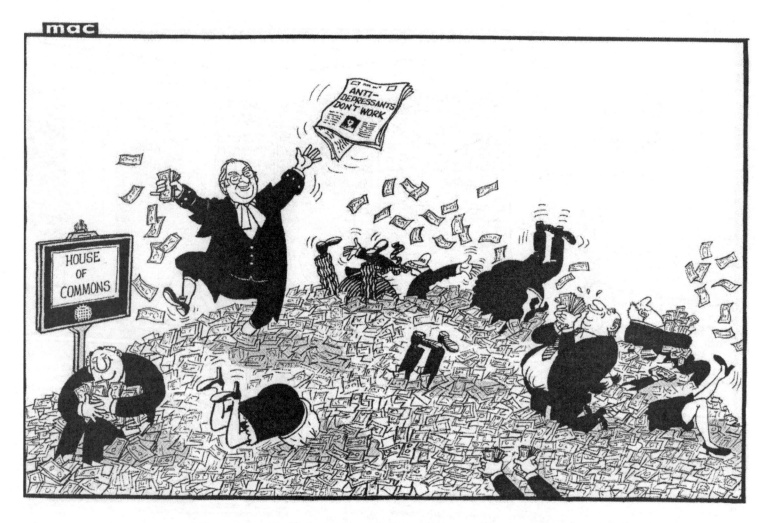

'Who needs pills? I find this stuff always cheers me up.' *27 February 2008*

Chancellor of the Exchequer Alistair Darling prepared his first Budget, the first one in a decade to be written in close consultation with No.10.

'Don't be so impatient, Alistair. You'll get to read it on Wednesday.' *11 March 2008*

41-year-old Lib Dem leader Nick Clegg revealed in an interview for *GQ* magazine that he had had 'no more than 30' sexual partners but added: 'It's a lot less than that.'

'Normally politicians just ask for your support – but wowee! Not that Nick Clegg!'
2 April 2008

A 73-year-old Austrian man was arrested after keeping his daughter locked in the cellar of his house for 24 years. Meanwhile, the memoirs of former Labour Party fund-raiser, Lord Levy, claimed that Tony Blair had been given 'long massages' by former topless model Carole Caplin while Prime Minister.

'Answer the question, Tony! How long have you had Carole Caplin locked in our cellar?' *29 April 2008*

The Labour Party had its worst local election results in 40 years and Tory Boris Johnson defeated Labour's Ken Livingstone to become Mayor of London. Meanwhile, former premier Tony Blair bought a £4 million stately home in Buckinghamshire once owned by actor Sir John Gielgud.

6 May 2008

As a poll reported that 55% of Labour voters thought Gordon Brown should quit, Scottish Labour Party Leader Wendy Alexander defied the Prime Minister's official stance and called for a referendum on Scotland's independence from the UK.

'I've tried, I really have. But does anyone seriously believe in Gordon Brown?' *9 May 2008*

Two new autobiographies by Labour Party insiders – *Prezza: My Story* by former Deputy Prime Minister John Prescott and Cherie Blair's *Speaking for Myself* – portrayed Gordon Brown in a negative light during his years as Chancellor.

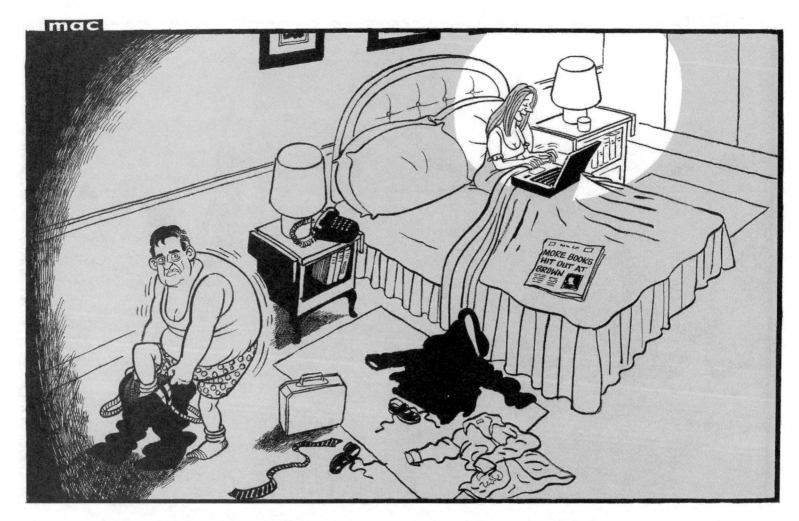

'I suppressed a whimper of anticipation as he tore off his clothes revealing his fine toned rippling torso...with one bound he was by my side, breathing into my ear his plans for the Crewe by-election...' *13 May 2008*

In the face of increases in the cost of food, gas, electricity and petrol, rebel Labour MPs backed a Commons motion to reconsider plans to introduce higher road taxes on large family cars, seeing this as a recipe for political disaster.

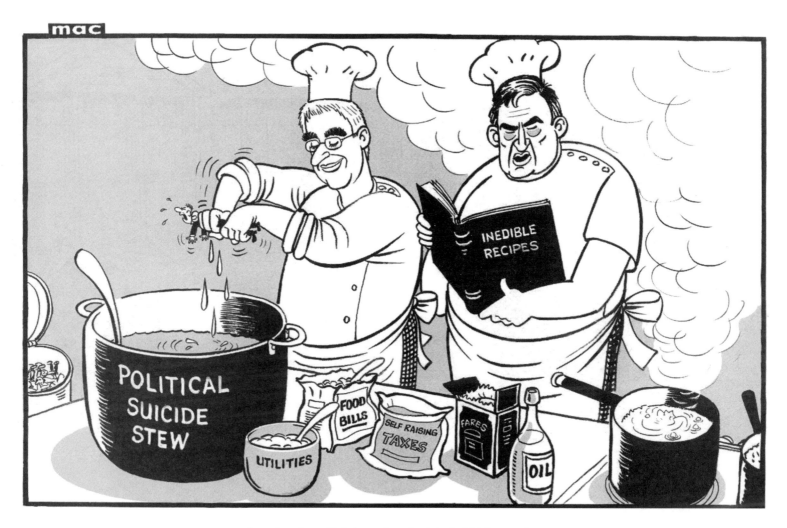

'...saturate with juice of motorist...' *28 May 2008*

Carol Vorderman resigned as co-presenter of Channel 4's *Countdown* after 26 years when she was told that her £800,000-a-year salary would be cut by 90%. Meanwhile, during Gordon Brown's holiday in Southwold, Suffolk, there were more calls for his resignation.

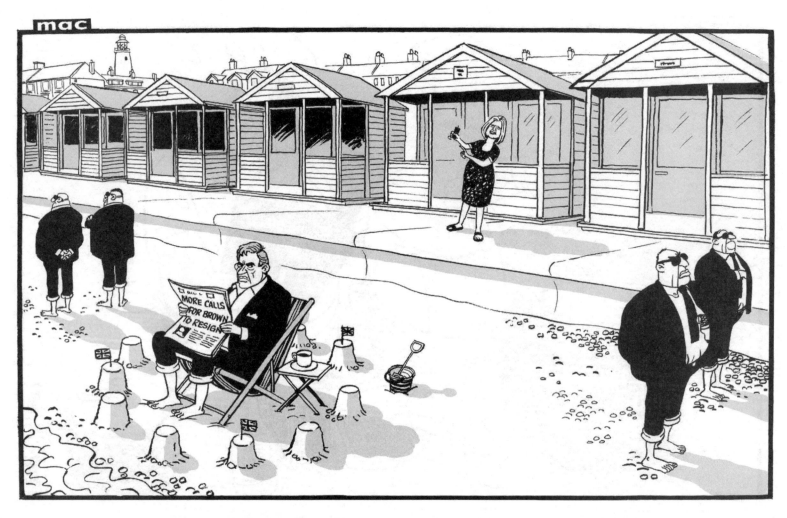

'Great news, Gordon. They're looking for someone who's cheap and reasonable at sums to replace Carol Vorderman on *Countdown*.' *29 July 2008*

A 900-word article published in the *Guardian*, which set out Foreign Secretary David Miliband's personal manifesto for beating the Tories, was seen by many to be preparing the ground for a Labour leadership battle.

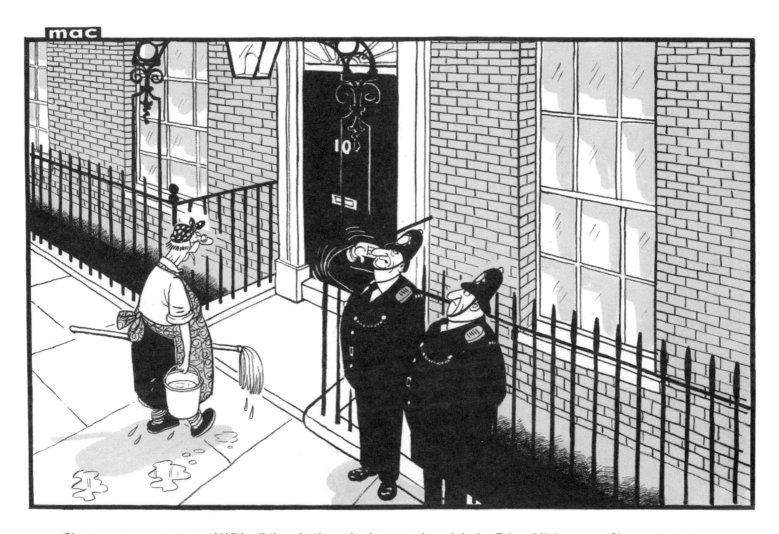

'Show some respect, man! With all the plotting who knows who might be Prime Minister next?' *31 July 2008*

Attorney-General Baroness Scotland, the Government's chief legal officer, was fined £5000 for breaking immigration laws when it was revealed that her 27-year-old Tongan housekeeper had overstayed her student visa by five years.

'I'm sorry. No documents, no job – we don't want a Baroness Scotland situation here.' *23 September 2009*

'I feel my life is slipping away. I've only **another 48 years of not working till I retire.**' *7 October 2009*

Following the MPs' expenses scandal, a committee of inquiry chaired by Parliamentary Standards Commissioner Sir Christopher Kelly banned second-home claims for MPs living within 60 miles of Westminster and the employment of their relatives.

'Darling. I bear devastating news. I have to replace you with someone who is not a relative.' *29 October 2009*

As MPs' expenses continued to dominate the headlines, the *Daily Mail* ran a feature on Guy Fawkes Day by historian Dominic Sandbrook entitled 'Would Britain Really Be Any Worse if the Commons Was Blown Up Tomorrow?'

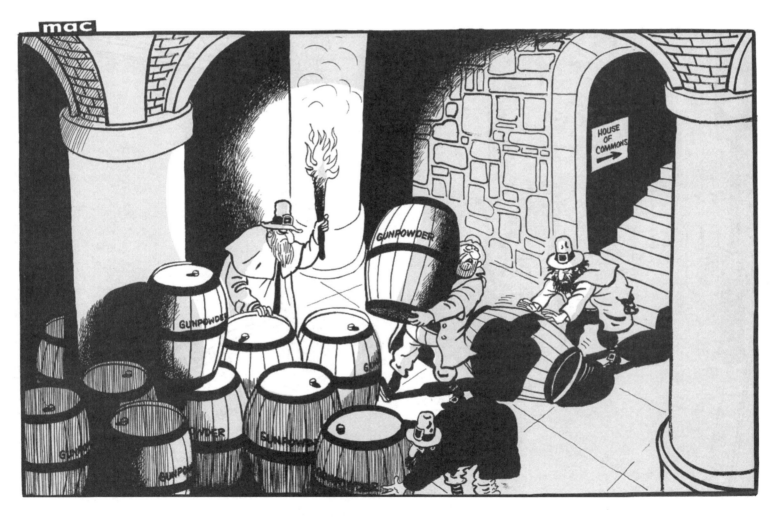

'After this, can we talk about my expenses?' *5 November 2009*

On the first day of the official inquiry into the Iraq War – widely regarded as former Prime Minister Tony Blair's greatest foreign policy disaster – its Chairman, Sir John Chilcot, declared that it was not a trial and could not determine guilt or innocence.

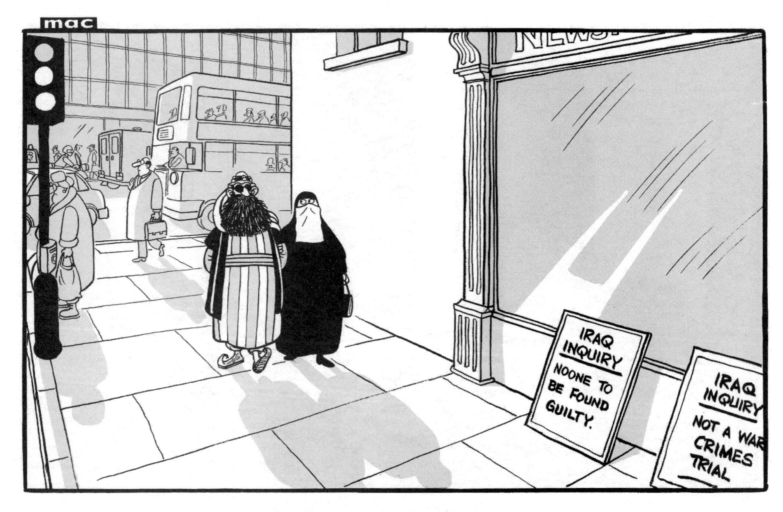

'Phew! That's a relief. Can we go home now, Tony?' *25 November 2009*

Critics of the 12-day Climate Change Summit in Copenhagen claimed that flights, rail and bus travel, food etc for the 15,000 delegates would generate more greenhouse gases than produced by entire countries such as Malawi or Sierra Leone during the same period.

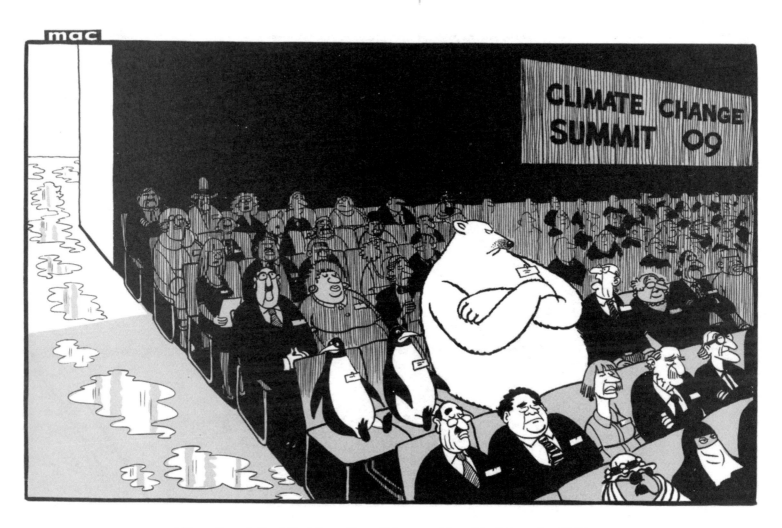

'Okay, Smart Alec! So I flew. How did you get here?' *8 December 2009*

After 18 months, Prime Minister Gordon Brown declared that the recession – Britain's longest ever – was finally over. However, it would be a long time before recovery became evident.

'The recession's over – let's party!' *27 January 2010*

A shock opinion poll suggested that the Conservatives' 20-point lead over Labour in summer 2009 had dropped to just two points, enough for the Labour Party to win the forthcoming election and remain in power.

'Yes. I'll be voting Labour – how about you?' *2 March 2010*

As the election campaign began in earnest, Health Secretary Andy Burnham unveiled a compulsory 10% 'death tax' levy on the value of a person's estate to pay for social care for the elderly.

'Cyril, it's for you. I think it's some bloke canvassing for the Labour Party.' *12 March 2010*

In a Channel 4 TV 'sting' operation in which reporters posed as representatives of a US lobbying company, former Transport & Business Secretary Stephen Byers said he was a 'cab for hire' and offered to influence Government policy in return for cash.

'Damned cheek! That bloke Stephen Byers is on my patch again!' *23 March 2010*

Samantha Cameron, wife of the Conservative Party leader, announced that she would be having a baby in September. If the Tories won the election she would be only the second Prime Minister's wife in 160 years to give birth while living in Downing Street.

'Never mind what sex it is – is it a Conservative?' *24 March 2010*

The UK Independence Party unveiled its new campaign slogan, 'Sod the Lot', urging disaffected voters to ditch the three main political parties.

'I think your postal voting form from UKIP has arrived.' *15 April 2010*

The election campaign reached new heights with the first-ever televised debate between the leaders of the three main parties. Meanwhile, ash from the erupting Eyjafjallajökull volcano in Iceland caused travel chaos with many airports closed.

'Hello. British Airports Authority? Cancel all flights. My husband has erupted!' *23 April 2010*

On the eve of the third and final TV election debate, Gordon Brown unwittingly left his microphone on after a meeting in Rochdale with a lifelong Labour supporter who had raised the issue of immigration, calling her a 'bigoted woman'.

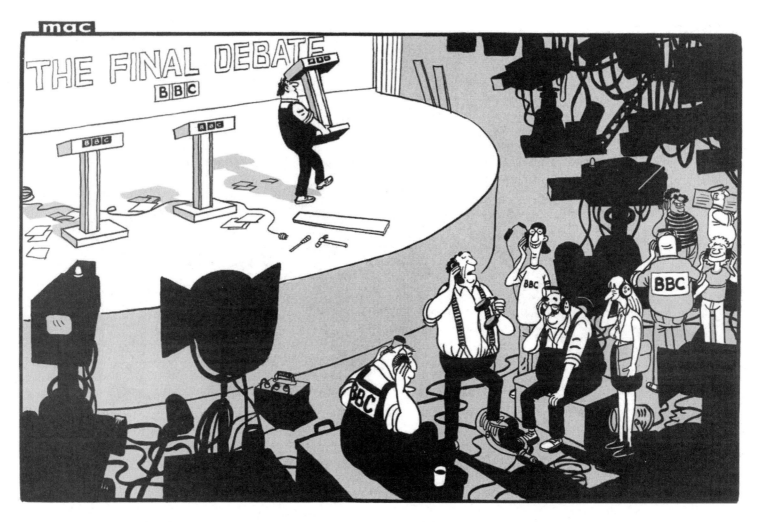

'All right, Prime Minister. I'll tell you how I know you're in the bath sipping whisky and shouting at your plastic duck – you've left your microphone on again.' *30 April 2010*

The Duchess of York, exposed in a televised 'sting' set up by the *News of the World*, offered to arrange a meeting between a fake businessman and Prince Andrew for £500,000. Meanwhile, the Queen's Speech opened the new session of Parliament.

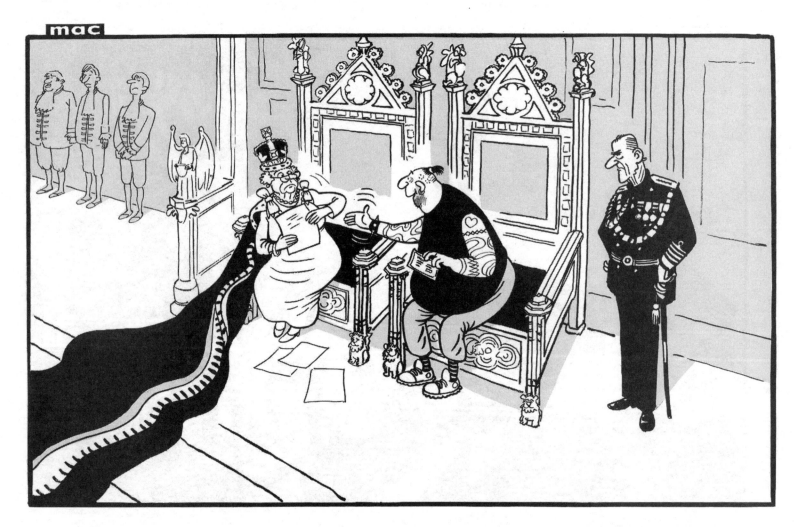

'That's right, Ma'am. I bought a ticket from "Fergie Enterprises". Meet the Queen – a hundred quid.' *25 May 2010*